MW00528851

Steven D. Lavine –
Failure Is What It's All About

Jörn Jacob Rohwer

—

STEVEN D. LAVINE – FAILURE IS WHAT IT'S ALL ABOUT

A Life Devoted
to Leadership in the Arts

ESSAYS AND CONVERSATIONS

DEUTSCHER KUNSTVERLAG

My father always used to say the best thing you could do was to be a doctor: "You get to do good, you get paid decently, and you get the respect of your community." He wanted my siblings to be doctors. He wanted all my friends to be doctors. He just thought it was the ideal occupation.

When I decided to become a literature professor, it was for related reasons: introducing people to the community of shared suffering that makes you a human being. I used to feel very strongly about it. I couldn't think of another choice that felt as valuable and I carried this with me while teaching.

Working endlessly, I became a really good teacher, a good lecturer especially, winning awards. But I didn't have the certainty that independent scholarship demands—my second-guessing of everything made it very difficult for me. Besides I hated inefficient committees, a core aspect of regular universities. On some deep level I knew I wasn't cut out for what I was doing. By the end of it I was pretty desperate—in fact, I was even panicking. But I didn't know what else to do.

Steven D. Lavine in conversation with Jörn Jacob Rohwer

A project facilitated by the generosity of
Daniel Greenberg and Susan Steinhauser

CONTENTS

UNDER THE SHINING ARMOR

<u>UNRAVELLING STEVEN D. LAVINE</u>

Janet

She walked down the stairs that led to the lobby. Moving slowly, almost hesi-tantly, she spotted me there waiting, waving in her direction. We hadn't yet met.

As I got up from the bench to reach out and welcome her, she looked at me, then paused for a second, then exhaled unexpectedly: "I think I've known you for all of my life!" What a statement. Had anyone, and even more a strang-er, ever embraced me with such disarming sympathy? While stepping further down, she suddenly lost her equilibrium. Without even touching the freshly polished ground, she slipped, and came to a fall before my feet.

This is how I first met Janet Sternburg, the wife of Steven Lavine, some fifteen years ago in Berlin. Introducing you to her is also a way of presenting a fuller image of him, even more so when reflecting on who she is in the above-described moment: self-assured about her instincts, spontaneously expressing her thoughts, words, and deeds—and then, occasionally, being so involved with her own complexity that it overwhelms her, at times even knocks her off her feet. Without telling you something about Janet, the woman married to Steven for more than thirty-five years, there would be less an understanding of the man he is. Besides, the foundations of my friendship with him go back to her. Without Janet, even this book would not exist.

Initially a mutual friend had the good inkling to point me to Janet's writings and photographic art and suggest that we should meet. Taken by what I read and saw of her works, though without knowing the artist personally, I sat down to write an essay, trying to understand what makes her manner so unique: Janet has will power. She is not very tall but seems to physically grow when you are with her. Her vibrant spiritual presence is shaped by life experi-ence, learnedness and, the many places she has travelled or lived, among them Boston, New York, and Los Angeles. Janet exudes a glimmering beauty, accen-tuated by fine garments in complementary colors and extravagant jewelry.

Being a worldly American, Janet has an air—a melodramatic, self-assured sense of being Janet. She doesn't enter a room, she seizes it. She doesn't just engage in a conversation, her mind is ahead of it. Whatever category you'll try to put her in, she'll resist it. Janet will always be the independent spirit she already was in the early 1960s, when she left home with nothing but a suitcase to take the bus to New York City: volatile, determined, ready to conquer her universe—as a filmmaker and producer, as a writer and photographic artist. It is her very own, shrewd vision of the world that makes her so inimitable: her way of detecting and unraveling layers that generates an optic, spiritual, or emotional nerve and, by doing so, reaches deeper than any scientist or therapist could.

Born and raised as the offspring of a family descended from Russian Jews, surrounded by ambitious neighbors, melancholic aunts, and a mentally challenged uncle, she lived with her parents in bourgeois confinement, under the spell of the McCarthy era and far removed from the American Dream. Early in her childhood, it was a symbolic act for Janet to close doors behind her so that she could be in solitude—her only way to find access to her "own world," as she remembers, "beginning to speak, through writing."

Fragile and ailing at a young age, she had to stay in bed for a whole year, guarded by her mother and educated by a private tutor. She was a talented child, transient and bright at the same time, who would later recall everything adults sought to hide from her: "As in bodies, the wounds of history have layers, extending through generational strata," Janet writes in one of her essays, many years after she had left home and moved to Manhattan, where she studied philosophy, wrote articles and poems, establishing herself socially and professionally. When her first marriage broke apart and she was diagnosed with cancer, her life changed. "No one survives intact," says Janet. "No one is exempt. In that democracy of sorrow lies our consolation."

Janet's literary descriptions are free from tearful sentimentality, penetrated with hope and filled with a need to comfort others, which is the function of her art as she sees it. The motif of memory that dominates her work as a writer also appears in her photography—those optical puzzles consisting of arrangements in multiple layers and interiors, which seem coincidental and yet are consciously set in scene, always referring back to the artist and her lyrical view. Her images can be understood as both a school of seeing and an iconography of memory. With her vigilant, highly sensitive outlook, Janet, like so many US

Steven D. Lavine and his wife, Janet Sternburg, Los Angeles, 2015

artists and intellectuals, embodies the other America: a continent of multiplicity and richness of those voices, colors, and thoughts shaping a universal consciousness, and standing in opposition to the dominant "culture" of denial. Janet knows exactly what reality is like, even if she manages to display it in different ways through the words of her writing and through changing lights in her photography. What she sees and describes is present and true. How she sees and describes it, however is lyrical, performative, extremely specific and in a rare, completed way, free. Janet in a way is so different from Steven, it's funny, fascinating, and revealing. To me the two of them seem like batteries of different voltages with one another, constantly emptying and recharging.

As you'll learn from this book's conversations, it wasn't Steven but Janet who led the way when it came to deciding about leaving New York and moving to Los Angeles, where CalArts would hire Steven as its new president. Janet, for the good cause, inspired, advised, and supported him in more or less any substantial decision to be made in the subsequent thirty years. And yet, not every-

one was "happy" with that. Ask her about the reality of empowerment and she'll teach you a lesson on other women of her generation, trying to talk her down as being "the wife"—not even considering the possibility of a reversed reality. But Janet has fought her way through: being heard by giving her own speeches, being read by writing her own books, and being seen by exhibiting her own photography. She has taken her own stand without ever leaving Steven's side. That to me is true empowerment, paired with strength and loyalty.

If you have the chance to read Janet's most recent book, White Matter (which took her years to write), about an America and an unsung family history, you will get a feel for who she is. The same is true if you take a look at Overspilling World, her latest book of photography. In a way, Janet is an unsung person, too. It takes someone extraordinary, someone very bright, knowing, and understanding to counter and sustain her abundance and her brilliancy. That someone is Steven.

Steven

It strikes me that, as opposed to Janet, I cannot recall when I first met him. Was it at a dinner party or at the opening of a show of Janet's works in Berlin? I'm usually better in remembering a person than a place, a situation, or chronology. What I do remember is that initially I had a hard time figuring out Steven's physiognomy. His facial expressions changed quickly and seemed somewhat hard to unravel to me. Having conducted at-length conversations for thirty years, I consider myself rather well versed in deciphering my counterparts' mannerisms. Not so with Steven. Was he looking away or actually looking at me? Was he hiding behind a fence despite being warm and engaging in his demeanor? Perhaps, I thought, I had met a person who, while sparkling with knowledge, interest, even enthusiasm, was nice, but after all "just being very American," as people in Europe might say when uncertain about the true nature of someone from the United States. I was in my late thirties then, about to publish my first book but hard to pin down both as a person and as a writer with a rare professional focus. Perhaps Steven, too, had a hard time figuring me out and thus remained kind of restrained.

Unlike Janet, Steven can be quite hesitant when it comes to making friends or decisions. He's much less lead by his intuition but more so by a process of

careful, thorough thinking. It's only over time and when a special bond or kinship develops that he might open up or eventually call someone a friend. He may be sociable in public, treat others courteously, even gently but still remain a fairly exclusive human being. To my understanding his exclusiveness, as is often the case with outstanding people, is rooted in a profound melancholia—and not without reason: What does it imply if being alone in a nightly nursery, unavailingly crying for someone to attend to you, is one of your earliest memories? If your childhood was shaped by a mother who, after failing to succeed as a concert pianist, struggled with depression and fatigue? If art seemed the only place for you worth being because the town you grew up in had nothing more to offer than a few forgotten streets?

Born into a family of second-generation immigrants from Eastern Europe, growing up in Wisconsin in the 1950s, a high point of conservatism, Steven turned into a quiet boy, books being his outstanding fervor—a world full of stories giving him comfort and refuge. Trying to overcome his shyness and discover what his destiny was going to be must have been both a fright and a temptation. Popular magazines and television shows, or trips to larger cities had a certain impact on him in his early years. Then scholarships, good teachers, and Bob Dylan's lyrics helped him to come of age. But the work he had to do himself—and most of the time there was nothing but work for him. The expertise that came with it over fifty years was what most people would appreciate, while only few would look behind the fence or "the shining armor" as Steven would call it.

When he agreed to talk about himself for this book, it challenged and encouraged me to evoke in him his most significant reflections and memories. Because, interestingly, men of his rank are honored for their professional merits quite frequently but are often overlooked as personalities. It's the acclaimed artists who take their seat in the front row when it comes to public acclaim, but much less so those who have facilitated their careers in education.

It may not come as a surprise that Steven is a humble fellow, his voice being rather soft-spoken, his demeanor quietly observant. He never dresses up but comes in gray suits, a pair of fancy eyeglasses or an elegant tie being what one could call the peak of his allure. I always wondered what it was that attracted him to a career in the arts field. Because it didn't seem obvious and to my knowledge no one had ever asked him about it. Having worked for a

prestigious foundation and being designated to run an arts school were to be sufficient reasons. Therefore, from my professional perspective, it seemed self-evident to approach him through his biography.

Among others things I learned that his mother's misery had left its mark on him, but that creating better opportunity for those choosing art as a profession helped him cope with feelings of self-neglect and insecurity. An even greater challenge—in fact an earthquake—helped him realize he owned the will, strength, and stability to act accordingly, when Steven lead CalArts from plight to prosperity. Being a moral person, Steven seeks to turn the world into a better place. Resembling his father, a medical doctor, who often worked long hours and treated indigent patients free of charge, Steven, for the longest time, burdened himself with work to serve the lives of others. It made him happy to see them grow and flourish. Yet to a certain degree it also left him unaware of himself—and lonely.

Initially I didn't regard this as an obstacle to our sittings. Anything I had prepared was tailor-made to set his mind in motion. All he needed to do was show up and be himself. But then I realized that in a way this was the problem: If focusing on others has been the primary obligation for most of your life, then what is there for you to say about yourself? Where to begin, what is right or wrong and what is important? As much as it had already been hard for Steven to mark our appointments as mandatory in his calendar, he seemed to have a hard time allowing himself to be the center of attention. Eventually, I assume, he quietly resolved to get past the uneasy questions in order to move onto subjects that seemed to him more suitable for conversation. But I didn't let him get away with it.

Sycamore Avenue

I arrived in Los Angeles barely two weeks after my mother's funeral. My father had been laid to rest six months before. Taking off from Berlin, rising up into the sky and gliding through the clouds seemed somewhat unreal to me—like being in the middle of nowhere, between hope and grief, ending and beginning. Losing a mother causes a state of uprootedness—comparable to a sense of grounding or trust in this world that all of a sudden and ultimately disappears. What occurs instead is the profound realization that henceforth anything in life will be lived differently. Without yet clearly knowing, my life was at a turn-

ing point, about to change significantly. What I felt most at this point of time was uncertainty.

LA was a very strange place to arrive in in such a state of being. I would have preferred entering a peaceful island. Instead I found myself defensively shuffling through darkness and across hellraiser highways until I finally reached Sycamore Avenue in West Hollywood, where I moved into the apartment of a friend who was away teaching a term in London and Paris. That night, closing doors behind me, was a huge relief. It ended the next morning when I found a ticket on my vehicle's windshield and learned about the local rules of weekly street cleaning, according to which parking your car can be either allowed or temporarily prohibited.

A few days after settling in, the conversations with Steven were to begin. Coming from the Arts district, he had already squeezed himself through traffic for about an hour or so upon arriving at my place. He would ring the doorbell, salute me with the friendliest of smiles, walk in and take a seat by the dining table, where drinks and little snacks were held ready. Steven on one end, me on the other, the tape recorder between us, was how we started around 10:30 in the morning. We usually worked into the late-afternoon hours, interrupted by a lunch break, during which we walked to one of the cafés or restaurants nearby on La Brea.

With each day he came to see me Steven seemed more relaxed and relieved. Was it because he finally got in touch with himself, gave way to his memories and shared them unrestrictedly? At some point, I think, he even started to enjoy my questions and our conversations, notwithstanding their length or complexity.

There were moments in which his mind seemed to drift far into the past, searching for a hint of truth or, perhaps, a moment of epiphany. Contemplating his mother, I could almost feel him yearning to reach out to her, his feelings ranging somewhere between love, gratitude and grief. Given their emotional complexity these recollections nearly overwhelmed him. Steven would start to speak, then pause, retry, continue and finally either change the subject or start all over again. Either way, I had plenty of notes ready to help him refocus and go back in the direction we had initially started to take.

Some of Steven's notions keep ringing in my ear. Such as the fact that he never thought he fit in socially. I wonder if that is an unusual or rather typical thing for a successful man to say. Isn't any kind of individual success based on making a difference? On overcoming one's own self, standing out and solely competing against the majority? The kind of misfit or failure Steven addresses in our conversations seems to me one he only touches upon instead of speaking about it consciously. This neither relates to his professional success nor to his intellectual achievements but to personal choices—moments in life, when he decided to ignore his inner voice and listen to reason. Such as bearing the silence of his family and taking refuge in alienation. Such as flirting with being a beatnik or yearning to become a writer and then preventing himself from doing so. Loyalty to his father and fear of his mother's fate kept him from being fully self-confident and exploring his own limits. However, at the same time this deficiency lead and enabled him to admire and support a world he would never allow himself to seize professionally: the world of art and autonomy artists generate by leading nonconformist lives and making radical decisions. Serving and enrichening this world by founding CAP (CalArts Community Arts Partnership), Steven has managed to provide opportunity in the arts for innumerable youth. And, what's more, by guiding CalArts through almost three decades he has helped thousands of prospective artists to facilitate, improve, and establish their careers.

Besides, CalArts—at one time basically a traditional, white, middle-class institution—is now one of the most economically, ethnically, and gender-diverse arts school in America with 40–60% students of color, 20% international students, and a high percentage of LGBTI students and alumni, of whom many have become widely acclaimed professionals. Giving opportunity to the truly gifted regardless of their background and thus turning the school into a place of somewhat universal freedom is what can be called Steven's proudest achievement.

He may not have had the strength to be true to himself in his younger years. Perhaps that is what Steven, when looking back, identifies as his failure, for it has shaped his early biography. However, more importantly, is that Steven aims to reflect and reveal this and perhaps, by doing so, becomes more at one with who he is. He might also be regarded as being more authentic by others, particularly artists, demonstrating that, like them, he is one-of-a-kind but in the very first place: a human being.

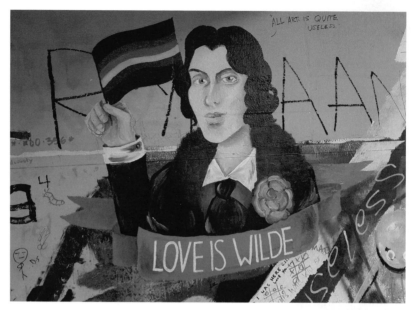

Student graffiti. CalArts hallway, Los Angeles, 2017

Failure is a paradox. On one hand it is something we deliberately try to hide, with shame being the emotion likely to best reflect it: Shame about wasted time and missed opportunities. Shame about people we may have treated disrespectfully. Shame about who we are or how we feel. On the other hand, failure has its own potential. As a gay man I know it takes courage to get out of your shell—but that eventually being true to one's self is empowering. Steven has allowed us to see the world through his eyes by opening up in these conversations. He has given us the chance to look at him closely, even intimately. Most men in power positions try to keep up an image of infallibility, even though we all know it is too good to be true. With Janet standing by his side Steven has managed to take off the shining armor, display a multitude of personal and intellectual layers and open up to change. It makes his light shine even brighter. That to me is what failure is all about. At least eventually.

Jörn Jacob Rohwer
Berlin, Summer 2020

STEVEN D. LAVINE IN CONVERSATION
WITH JÖRN JACOB ROHWER

A LUCKY MAN

**If I were to characterize you briefly, Steven,
three words come to my mind: strength, doubt, nobility.**

> In fact, I am a compromiser. Which is not at all times compatible with
> nobility. But I aspire to a kind of decency. Leading an ethical life and
> trying to live up to a sense of ethics relates to my Jewish upbringing.
> As for strength: I'm terrible in a crisis. I'm paralyzed until there is
> a kind of settling or a hunch that something feels like the right thing
> for me to do. It's only then that I turn into a rational, calm thinker
> who, with a sense of direction, can go on endlessly. So I guess it's
> more of an endurance. But still there's a lot of doubt within me.

Where does your doubtfulness come from?

> At some level it's inherited from my mother. She kept a kind of
> baby-book during the first months of my life, in which she noted her
> reflections on what she was seeing in me, but also criticized herself
> for anxieties she was passing on to me. Constantly worrying about
> what the next thing was she ought to be doing, she found she was
> making me a nervous baby.

**Have you later in life been able to handle
your worries and doubts somewhat self-beneficially?**

> They ruined me as a scholar, because I was unable to reach decisive
> judgements. In an argument with myself I could always see the
> argument against my own. While working on my PhD dissertation,
> I felt I could say the opposite thing for almost everything I wrote,
> and it would almost equally be true. That's why for many years I hated
> writing—because I really had to choose. But as CalArts's president

I came to realize that doubt was one of the best tools I have. Because in bringing people together, embracing a process of different voices and weighing arguments I gradually felt my way through to what was ultimately the right thing *for me* to do.

Constant arguing with oneself seems to me a very Jewish thing. It's what rabbis do, trying to give advice, creating learnedness. However endless worries and doubts can also lead to confusion.

And I create a lot of confusion around me, including in my work. Because of my not being clear enough myself or to others about what's next to do. Janet even picks it up when we're on the freeway: "Is *this* the right exit?" she asks. And I reply: "They say, this is the exit." But then I go on doubting it: "Am I remembering it properly?" And Janet gets really annoyed and says: "Why are you hesitating—we just decided the exit is two exits down! You know where it is *now*!" But somehow I forget. I'm always second-guessing myself. Fortunately my wanting to live up to a fairly high standard of decency gives me an index of what I really ought to be doing in many situations.

Looking back it seems you have been very lucky: degrees from Stanford and Harvard, a long, outstanding professional career, a fulfilling marriage, trips around the world, people who admire you, multiple honors, public recognition ... —would that be the full picture or is anything missing?

Well—on one hand my life's been very lucky. But equally true is that I have never built really strong human relations with other people. I've gotten along well with others, built bonds of colleagueship, but not what seems to me what friendship ought to be.
I always felt such obligations to CalArts that there was no time for anything else—no real time for friends, time off the clock, or off the agenda, unless I was fundraising from them or we were talking business. Part of that problem goes back to doubt again. To a fear of failure. There was always the chance I could do better for CalArts if I put in more time. Which is what I did. But I was basically by myself, not making connections. So in that sense I've spent most of my life feeling mildly depressed and pretty lonely.

Because you chose to be that way or because you couldn't help it?

> I couldn't help it. I feel that outwardly my life has been very successful, but inwardly there's a hole—and that now I have the opportunity to sew it together by talking to you.

ARTIFACTS

**Let's start by talking about the arts. I'm interested in knowing
how you connect to art—what it evokes in you. Because art
as something being free of borders seems in a way opposed
to a mind as intellectually trained and focused as yours.**

You think so? A lot of the art I see is interesting, inspiring, intriguing
to me, giving me new impulses. CalArts in this respect has given me
more of that than anything. Music for instance—I hear all sorts of
sounds that I once didn't understand as music. I have a much broader
range of what I can hear than in former years. That's valuable itself.
But the ultimate purpose of the arts for me is guidance as understan-
ding something more about who we are and what this life is for. The
fact that artists don't have to prove what they say lets them be ahead
of other kinds of thinkers. They don't have to have all the evidence;
they just have to assert their vision in a way that's persuasive. That's
why I want the arts to reveal something to me about human life or
about where the world is going.

**You're talking about the purpose art has for you
and how it spins your intellect rather than what art evokes in you.**

I see the difference, but I don't accept it. I think it starts by gripping
you and then you ought to think about it. It's an intellectual
approach—you don't settle for just being gripped. It's not an accident
that literature and theater are the arts that speak to me most power-
fully. Music has an even more special place for me. It grips me in ways
I cannot articulate, giving me clues about my emotional side I tend to
have little access to in my daily life.

**But that's pretty much what I'm asking you to talk about:
how your physical, spiritual, and emotional access to art actually proceeds.**

Let me give you an example. I remember the first moment after 9/11
in which I felt a little better about the world: a dance concert. It was
so wonderful that someone could leave the ground—it seemed like an
affirmation of human spirit that this person could leap across the stage.

My heart lifted before I attached a meaning to it. I grant you that. But my relationship to art is almost always trying to find the meaning beyond that. It's not enough just to experience it, but how you process it.

So you prefer art to be seen in a larger context, adding to it a social, political, or philosophical meaning?

Yes. Because often I see or hear something and react to it but can't quite get to what I'm feeling. Janet is very responsive to art emotionally but she can also think her way through to its meaning, whether it's visual arts or music or whatever. She's a great interpreter, and I love that about her.

How do you define art?

More than anything I define it by being better than it has to be. We have a life that's filled with good-enough: good enough to function, good enough to get by versus something that lifts the spirit beyond it. A chair you can sit in is good enough. But think about an Eames chair. It's that difference.

How about *White Painting [three panel]*, by Rauschenberg, soundless music by John Cage, or installations without a deeper meaning? Would you regard them as better than good-enough, too?

When you do a blank canvas you're responding to something about the world that requires rethinking. That and all kinds of other visual arts are helping me to see—whether Cezanne demonstrating how solid the existence of an apple may be or Ai Weiwei surprising me with his portraits of prisoners of conscience made of Lego. When you look at them, being so broken up, you will hardly see a face. Then you step back and suddenly it appears. You have to look until you see that there's a person there. The artist makes you spend time with these prisoners. And that is pretty amazing.

John Cage on the other hand teaches you how to listen—that silence is filled with sound and anything can be music. That translates into both experience and meaning almost immediately. And what it does is shock you into a state of being: first there was the feeling that it

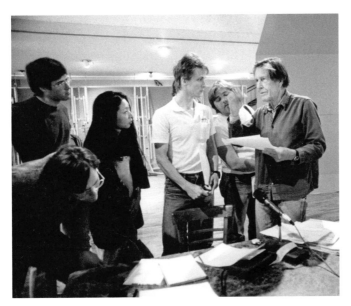

John Cage (right) with students at CalArts, Los Angeles, 1986

made no sense—and then you discover you're hearing things. However, I would generally say that all works of art mean more at their moment than at almost any other time. There are some works that end up accreting additional meaning as they go forward in part because so many people have valued them and they've influenced other artists in their ways of expression. But most works in art have their greatest impact as they jog you close to into some kind of fresh realization.

I wonder about the untainted reactions of a child, since these would be totally unfiltered. About a Pollock painting it might say: "So many colors!," about a Rauschenberg: "I can't see anything— no colors at all!"

I don't trust a child's response, as these works of art were not meant for children. The child's response says that there is something wrong with the canvas, as it lacks bright colors and isn't good enough or challenging. In fact, if you look at a white canvas there is a lot going on: There's texture, shadows, and visual elements. You have to pay attention in a new way.

I'm surprised you wouldn't trust a child's judgement.

> I trust it for the child. But I feel a greater responsibility as a human being that we make things conscious so we can act on them.

Sounds surprisingly conservative for the longtime president of a non-conformist arts institution.

> I should probably say that all these years I've had a sometimes more conservative taste in arts and culture than the institution I ran. I never felt I should try to impose my taste on the institution that had a particular mission. But I think there is something in trying to live up to the highest standards of what art can be. And I believe—probably more so than CalArts and Los Angeles do—in keeping your eye on what past greatness was. Not as of trying to duplicate it but as to say: We don't have to settle for less than that. We have to push towards something that is as broad and human and deep as the deepest art of the past. For a place like Los Angeles that's pretty hard. Because the freedom often comes from not respecting the past. And the downside of that freedom is not holding on to past levels of achievement that one can learn from.

Nevertheless Los Angeles is often described as the twenty-first-century's global creative capital. There's no city in the world that has places like USC, UCLA, UC Irvine, Otis, Art Center College of Design, and—CalArts. The movie industry and the popular music business have their own kind of fame. Though undefined in whatever final shape it may take, everybody in LA can feel that this is where things are happening—the place to be.

> LA has always been somewhat outside the main course of artistic developments. There's extraordinary energy here, a sense of possibility, a sense that the hierarchy isn't fixed. And this element of Los Angeles is freeing. The past doesn't have that much presence here, so you don't feel the weight of previous achievement. When I once asked the video artist Bill Viola how he felt about creating here in the belly of the beast (meaning Hollywood, because his works are set against what Hollywood is), he said: "Oh, it's great to be here. This is one of the few cities where you can rent an elephant." And he actually has an elephant appear in one of his videos.

LA is a powerhouse. Right now lots of energies are coming together here, and as popular culture takes a larger and larger place in the art world it helps Los Angeles to exert influence because it is a main line here. Berlin is a bit like that, for whatever reason. When you're in New York, Paris, or London, you feel the weight of what's been produced by history. That sets a standard for people, for artists themselves, but it's also intimidating. You play it a little safer when the establishment takes over and imposes one particular standard. But there is also the danger of becoming overly proud of what you're doing. In LA anything could rise and be the next big thing and get support for being more interesting. I look around and things are starting up. Things that shouldn't be able to happen, happen here. There's so much going on in Los Angeles—and so much that is recognized in one place and not in another. But I resist the notion of a global artistic capital—or of *the* global artistic capital. I think there are so many centers now, with Beijing as a leading global city, that we better get over that idea of a single capital. And, at the end of the day, Los Angeles still primarily looks to New York and Berlin. Or maybe I am the one still primarily looking to them but not Los Angeles.

Being widely travelled and having learned about humankind in many ways would you say that your awareness—your perception of light and darkness, beauty, and disgrace—has changed over the years?

Coming from a small town I was interested to see how people operate—how the world actually worked. I felt excluded from the present, like someone who'd been living in the nineteenth century, and therefore I grew up being curious. In seventh grade, when I went to a summer camp for Jewish children they showed us these Holocaust films. And what I felt was that in a way there was a generation trying to scare their kids into being Jewish. At the same time, what I told myself about it and still fundamentally believe is that people have their weaknesses and strengths and mostly are ok individually, but in groups or in a crowd there's no telling what they'll do or be. So quite early on I had a very mixed view of the world.

When I got to California one of the main lessons I learned was that pretty much everyone can be a good person on the one subject and

a not-so-good person on the other. I just kept encountering that again and again—in billionaires, in faculty, and everybody else. At the same time, I have always felt strongly influenced by eighteenth-century literature—its emphasis on human kind and generality. Samuel Johnson generalized about a common human nature—that there is not too much special about any of us; that we're all flawed, all wanting, and suffering pretty much the same ways. That is something I still believe, and it always reasserts itself. Over the years it's gotten even stronger and more universal for me, and it has led me to be quite ready to forgive people their failings. It has also helped me to make better decisions; decisions that are based on a true sense of values and made in reference to what I feel and believe. What I'm trying to say is that a sort of temperament within me was forged into something stronger, more prominent and present in my mind as an understanding of the world: something that was once just feeling has turned into something that is also reasoned. And that's terrific.

Contrary to all insight and well-weighed decisions, are there moments when you overlook experience and reason and just react spontaneously?

I wish I was the kind of person who's able to do that, but I'm not. Part of it is my own insecurity—that I don't trust myself. Part of it is deeper and inherited from my father—which is that there's always arguments on both sides: you wouldn't have an argument if there wasn't an argument against it. Therefore, if I made a quick decision, it often turned out to be not a good one retrospectively.

In opposition to that, an artist sometimes needs to clear his mind or page, canvas, or stage in order to generate a free impulse, expression, or movement. Intuition isn't always reasoned.

I think intuition often is about a kind of instantaneous act of reason, which works so quickly that it feels spontaneous. It's an approach I understand and appreciate. But at the end of the day I'm not an artist.

Let's take this opportunity and talk a bit about the arts and the US. Some say Americans like the arts but don't like artists.

"Americans" is a false category. There are so many different ways to be American that a generalization is almost impossible. It's like talking about the "Europeans"—you're describing something that people share, but it's a pretty loose thing.

I assume we're talking about the American art world, about a rather cultured or cultivated people.

Well, I believe that pretty much everyone has art in their lives in some way. It fulfills a need and might be fulfilled by not very good art, ashtray-art, but I believe that everyone needs something more beautiful, interesting, hopeful, exciting, or challenging beyond the existing routine. Americans in that are not different. However, there is this strong and pure kind of anti-art-streak in the US that goes against anything that might be considered frivolous. In a similar way many Americans are afraid of eccentric behavior. Or what they take to be eccentric. There I make a contract with the British who are just great at eccentricity. Americans are a little suspicious of it, assuming you're going to be tricked. And artists get caught in that fear.
The places in the US that are deeply, consciously art-invested are fairly limited and small (and I do want to separate that from the fact that there's a great number of regional theaters in the United States). People are easily intimidated by things they don't understand. (Much as I was intimidated by the thought that people knew things I didn't know when I was young—things that were too complex for me ever to grasp.) But as everybody is looking for something to make life less painful I think that art is actually fairly present in American culture. It's just under so many different guises.

So what about the artists—are they liked or are they disliked in the US?

Americans by and large have trouble understanding why someone would put more effort into something than it's financially worth. Though part of the essence of art is that it's better than it needs to be. It's not an efficient thing in the world. It's not at the minimum. You invest more labor than you're likely to get economic return. And about that, I think, there's a lot of incomprehension.

Allen Ginsberg at CalArts, Los Angeles, 1971

Incomprehension or disrespect?

It's both. But I think the disrespect comes from the incomprehension.
How can I say this...?: if you're British, Shakespeare comes with your
inheritance. It's essential to your identity as who you are. Pretty much
every European country has some level of unquestioned cultural
heritage—whether it's Goethe and Schiller, Dante and Boccaccio,
Corneille and Racine. And that's one of the great dividing lines
between Europeans and Americans.

What about Walt Whitman, Emily Dickinson, Ralph Waldo Emerson?

We do have people who fit that category. But it's rarely related to
American culture more broadly. And without that the arts have always
been on shaky ground economically. Art is often asked to prove its
worth on practical grounds. And that's why we don't support the
artists. Arts are not seen as essential unfortunately. When we formed
the National Endowment for the Arts and the Humanities underneath
of it all was that our politicians were worried about communism.
The fact that we had free expression and the Soviet Union didn't was
a reason to support the arts as proof that we were a free society. That's

how the arts ultimately won support by federal government—as our symbol of freedom.

Intended by John F. Kennedy...

Right. But it's been harder to make the case ever since real communism disappeared. And meanwhile a lot of people in America discover we no longer really believe in freedom anyway.

THE CONQUEST OF CREATIVITY

**You've always praised CalArts students as driven individuals
with something significant to share. You believed in them, raised
millions of dollars to help provide them an excellent education.
By doing so you not only served their artistry but also
the LA artistic community and, ultimately, the creative economy.
Now the tides are turning against free spirits and creativity.
As US-politics have changed, sheltered spaces in the arts
are increasingly regarded as a luxury.**

We're living today with a very degraded idea of creativity. So much
of what passes as art is just a little minor twist on what already is.
What one wants is a major twist. But it's an impatient world that
doesn't want to make the space for deep creativity. Remember the
Apple computer campaign that used the phrase "Think different"?!
I mean—give me a break: they had just come up with a machine!
Sure it took lots of cleverness to program it and make it do all sorts
of tricks—but the toilet was also an important invention! If you asked
someone, "Would you rather live without a computer or without
indoor plumbing?" I think most people would say they wanted the
latter. And yet we've let Silicon Valley persuade us that the latest
social media application represents creativity. It's good, but I still want
to separate that from actual art. Art is more than just a necessity. It's
better than it has to be. And it takes time to be made, to be recognized,
and appreciated. But we live in a culture that doesn't want to grant
the time and money to make that happen.
The current version of creativity argues that because so much stuff
already exists all we need to do is mix and match the parts differently.
You produce something that's temporarily interesting but not perma-
nently so, or not for a longer period. That's why in a college like
CalArts you need to emphasize the difference. On one hand you have
to prepare students to deal with the economy as it is. On the other
hand, you have to give students time and space to go deep and see
what emerges. There is a constant tension between those two things
built into the education: getting ready to make your way in an expen-

sive world with fewer and fewer safety nets and still to have the courage to make the space in your life to think harder about things and to produce something of real value. It's like the difference between invention and discovery.

When Laurie Anderson received her honorary degree at CalArts she gave a speech in which she mentioned a company that brought artists together to invent new online possibility. "Don't believe it when corporations says they want to support your creativity," she said to the students. "They don't want to support it, they want to use it to accomplish relatively short-term goals. And that's fine, but it doesn't mean that they care about the full depth of what is possible for you to do." We live in this world and it is what it is. I worry that I'm part of an older dispensation that is maybe becoming irrelevant. But I like it that CalArts prepares the students for this and at the same time constantly encourages them to resist it.

Do you believe that creativity, at some point, may be conquered by artificial intelligence?

I want to believe that there are depths of human experience that artificial intelligence cannot reach. Will it be able to feel the fear of death and ask how does one live with it? Will it be able to feel sorrow and ask what you do with it? Maybe we will eventually duplicate the neural system but surely that is a long way away. And the danger is that we settle for an idea of the human which is only what artificial intelligence can do and lose track of the elements of human itself that AI can't reach and then devalue those dimensions of life.

It seems hard to imagine that a machine should ever be able to generate an experience such as Proust's Madeleine.

I can't see it either and hope I won't live to see it. We're settling for a very disturbed idea of what the human is. If we leave aside the sphere of technology, governments and politics have pretty much reduced the human to an individual's economic being in the world and forgotten about everything else. Part of the reason why we see populist movements growing is not just people cut out of the economy but people who value other things—things that the global economy doesn't have any use for. These people fear that their concerns are

being left out of political debate pretty much completely. We've reduced everything to economics: a person is an "economic actor"—you're only as good as your economic contribution, not deserving to be supported. If you can't make your way as an independent contractor then it's your fault—doesn't matter that you were deprived of a good education, doesn't matter that you grew up hungry—it's a competition. Either you do something as an economic actor or you don't…—It's such a low version of the human.

Talking about the decline of decency and creativity, let us take a look at US wealth distribution and philanthropy: Americans view charitable giving as a responsibility to local social institutions and need in their community. John D. Rockefeller called his wealth "an accident of history," of which he saw himself only as the trustee. Though corporate gifts have come to be recognized as excellent forms of public relations (with education, mainly colleges and universities getting the largest share), 90 percent of all donations still continues to come from individuals. When you started at CalArts, the main donors were people who had an association with Walt Disney. The key donor, Michael Eisner, was on the board as president of the company and Disney was giving out of loyalty to CalArts and its traditions. Initially it must have helped that you knew the foundation world. But even over time you were extremely successful in raising large sums of money. Perhaps because it's in your nature to be lucky in winning over potential givers. It takes a lot of work, charisma, intuition, and experience.

It also takes interest. And I was genuinely interested in the people, always assuming the best, approaching them without skepticism. What donors commented on to me always was: my passion for CalArts. That's what they really responded to. And Janet's passion, too, because we were a good team. When I left CalArts, some donors or trustees thought of leaving the board. Nothing against my successor, but they said: "We don't know if we want to continue to be involved if you're not going to be here any longer." People want to be valued for themselves, not just because they have money. I actually found I couldn't raise money if I didn't respect a person or if it didn't involve a human connection. The fact that someone considered supporting CalArts already told me that there was something positive about this person,

whatever the negatives might seem to be. Because why would you do that unless you were interested in the arts and interested in possibility? In all those years there's probably nobody who supported CalArts whom I don't still respect at some level. Almost all of the funding came from individuals. Or from corporations where individuals needed a business justification but gave their support out of personal interest and commitment. They all saw that this was a unique institution and then chose to give. For many of them CalArts was also wonderfully exotic: not downtown, but just out of sight in Valencia, doing odd things but showing good results and embodying a kind of mystery.

Was there also a strategic element involved in your way of fundraising? Would you wait for the right moment whether or not to approach an individual?

That's how you're supposed to do it. Until the last, say, ten years I never felt I could do it that way. Our needs were too immediate to have a long-term strategy. And in most cases where I had a long-term strategy it didn't come out with a good ending anyway. It was much more making a social connection with the person or being introduced to the person by somebody they respected, sitting with them and talking about why this mattered. Then I would get them to CalArts. And often that was the determining factor—certainly if what they saw was this amazing energy everywhere unlike every college they'd ever visited: this sort of explosive feeling when you're on campus when just no one is hanging around but instead everybody has a personal mission. That pretty much was what won them over. A special example is Herb Alpert. When he first visited campus I could see the critical moment was when we were walking past the music practice rooms. Hearing one saxophonist he'd say: "You know, when he was playing alto, he sounded like Charlie Parker. When he shifted to tenor, he started to sound like Coltrane." That's what intrigued him. Because what he heard was real—these kids were actually going somewhere! And after that he started out giving for scholarships.

Would you let things wait for if or when a potential donor was going to make an offer, or would you at a certain point suggest that the person make a contribution?

> I would fairly quickly stress that these kids are betting their lives on their talents and how brave that was. As opposed to the first ten years when debt was not yet a major issue, I made clear that if we did not limit the amount they must borrow they're never going to get to be the artist they'd set out to be. Most of the gifts I raised until recently were twenty-five-thousand, fifty-thousand, a hundred-thousand dollars—and people could afford it. There were even some donors I went to lunch with who would say: "Why aren't you asking me!? Why are we having lunch if you're not asking me for money?!" And I was really grateful to those individuals who were clearing the air, behaving like friends.
>
> One of the nice things about being involved in philanthropy and certainly about being in a small institution is: you see the results. There's not a big, intermediary space. So much at a college involves committees, structures, and right ways of doing things. But if you can get someone to give money for a scholarship you don't need that big debate internally. It's real—you can taste it because it's so amazingly immediate! Most people don't like their fundraising. To me in some ways it was the best of all the parts of the job. You get together with interesting people and if they say no you've still had a conversation with someone you otherwise wouldn't have met. There are also people who do amazing things for your institution. And then there are those who become friends.

What does it take for you to call someone a friend— how do you, after all, define friendship?

> I just feel a kind of warmth in my heart when I'm in touch with a friend. And that person may not even consider *me* a friend. It's something that isn't reasonable. What matters is an emotional bond that is in no way instrumental. Unfortunately, much of our lives at CalArts *had* to be instrumental—because it would help the institution. Janet is not by instinct an instrumental person, it's not how she ticks. Whereas

I'm quite comfortable in that because I keep my protective distance. One of the great pleasures of not being at CalArts any longer and not having to fundraise for the Thomas-Mann-House is that if Janet and I want to see someone we can just call up to see them. I realize it's only now that I'm letting the emotional bond of friendship come to the surface and enjoy it where I can feel it.

At CalArts there were so many people I had to deal with that if Janet hadn't made us make the time I'm not sure I would have spent time with friends at all. There were people where I just missed the opportunity of friendship. Often they were running other not-for-profit-institutions and were fundraising, too, so we were both somewhat pulled away from both sides.

It's the personal price you've paid for being CalArts's president for almost three decades, all the while you saved, rebuilt, and renewed the institution and raised its endowment to one-hundred-fifty million dollars.

But that happened slowly, bit by bit, with a few big givers. Mostly it was cultivating relationships and staying in touch with people.

What would cultivating relationships include?

Usually getting together for lunch or dinner. Inviting individuals to see something at REDCAT or Campus.

For someone like Lillian Disney it also included CalArts students annually performing Christmas carols in front of her house until she was finally persuaded that CalArts deserved her support and she donated fifteen million.

That's a special case. Because she was someone who clearly should have supported CalArts anyway but had been disillusioned with it before I came and—even though it was almost kind of a family obligation to be doing so—kept refusing to give. Years before, while on a visit to CalArts, she had seen two kids running around naked, screwing in the grass and was pretty of appalled by it.

At a CalArts fundraiser with Janet Sternburg and Sharon Disney Lund (right),
Los Angeles, 1990

Why would that have been so appalling?

Lilian Disney was a very conservative lady. She was Midwestern, loved
her flowers and had her quite old-fashioned ways like Walt himself.
I had to win her back and get her to see that there was more to CalArts
than that. And that took time. And in fact, the fifty-million dollars
she gave to build the Walt Disney Concert Hall was money that was
originally thought to be set aside for CalArts someday.

Did you manage to keep yourself out of the notorious twists
within the Disney family?

I'd hear stories but kept focused on CalArts. I wasn't interested in
knowing those private affairs. For me it was being respectful to all
sides of the family.One side we never did win back, unfortunately,
was Diane Disney Miller's. She had once been an outstanding trustee
of CalArts but when Michael Eisner was hired her husband had been
fired as president of the Disney Company—and that was the end
of it. And in fact, part of the understanding, when Roy Disney gave
us money to build REDCAT (which would help get The Walt Disney
Concert Hall built), was that Diane would give up, well, not exactly
feuding but would reach out and rejoin the Roy Disney-side of the
family. However, at the very last minute she didn't attend the event
in which we were all standing together waiting to announce it. She

just couldn't out of loyalty to her husband I assume. Things get broken and once people lose trust it's pretty much for good.

Have you always been able to overlook what you personally didn't like about some of the donors: their vanity and super egos?

Yes. You try to overlook personal vanity, you try overlook social views which you might find offensive and try to recognize their positive values. But as I said before if there wasn't something that let me value a person besides giving money I couldn't bring myself to ask. I'm thinking about a trustee who was very negative about immigration but very positive about support for African-Americans. He didn't consider them immigrants as they'd been brought here by force a long, long time ago and have become citizens. A challenging view because many people who immigrate here are desperate—they're not coming to the US because they just want to but because it's a chance for them to be safe.

And yet you would avoid making the case for America as a nation built on immigration?

I would indicate my reflections but wouldn't indicate scorn for the other person's position. I would treat the issue as arguable. However, there was one case in all this time where I really lost my temper. It's actually an interesting story:
We had dinner with a Japanese banker who had become interested in CalArts and joined our board. He invited me to meet a Los Angeles city elder who'd done a tremendous amount for the homeless, for cultural organizations all over the map—in some respect for his generation the best citizen Los Angeles had. And over dinner he said the equivalent of: "People with AIDS deserve it." And I just—I just couldn't let it go it was just too awful. We didn't get in a shouting match but certainly raised voices—in a public place. His wife was trying to calm him down and Janet was trying to get me to back off. And mostly I was worried because our host was a very polite man whom I didn't want to embarrass. But this just wasn't acceptable. Of course this man didn't become a supporter of CalArts, I wrote him off entirely, even though I knew he'd done good things in the world in other areas. I never saw him again and basically had forgotten about

him altogether when ten or fifteen years later he sent me a letter, out of the blue, saying he'd been watching what we were doing at CalArts and how much he admired my accomplishments. And I thought, "Well, that's interesting—he can't have had many experiences of people raising their voice at him given his prominence and yet he has it in his heart to be still interested in CalArts." However I didn't have it in my heart to say, "Okay, you've got this awful blind spot, but you do help the homeless and that's really important, and probably you're helping some people with AIDS when you help the homeless, too, whether or not that's your intention."

By contrast to that some of CalArts's donors and trustees have become personal friends of Janet and yours, Herb Alpert and his wife among them. Alpert's donations and those of other individuals have been of great significance to CalArts's survival and success as a renowned institution. How did you manage while socializing with people of great fortune to draw a line between personal appreciation and professional relationship?

It's not a very firm line. People of significant wealth would draw that line for you. If you're Herb Alpert you're used to people wanting something from you, and so you're careful with your friendship for fear that it might be abused. I think Herb and I are able to be friends because in twenty-five years of connection we never have abused it. Working for CalArts I was not necessarily supposed to be making friends; and basically the closer you came to being real friends the more difficult it was—for me at least—to ask for support. As you might threaten your friendship and end up with divided loyalties. And that's very tricky.

There may be gifts I've waited too long to ask for because I just couldn't find the circumstances that felt right now that the person was becoming a friend. Also because there's a personal as well as an institutional part of the gratitude. I don't know if there were any cases where at the end of the day there was a direct conflict but it certainly became harder. There was an early trustee, a man named Peter Norton, who was phenomenally generous to us for many years and then lost interest for a variety of reasons. I'm still in touch with him though he no longer supports CalArts; but Peter helped to save the

With Herb Alpert, Los Angeles, 1990s

institute—he was there when we needed him and I can't tell you
what it means to me.

Did a donor ever personally surprise or astound you?

Herb Alpert—when we were talking with his representative about
making a fifteen-million-dollar-gift toward endowment in the music
school and he wanted to include what they call a "key-man-clause"
in the music industry. Which basically said that if a particular indivi-
dual were no longer involved (or if I left CalArts) the whole deal was
to be called off. However, I persuaded him that CalArts was so deeply
and fundamentally what it was (and is) that it would not betray the
vision that brought us together. And that we built around the fellow-
ship program we jointly ran, which had already been going on for ten
years, the Herb Alpert Award of the Arts. We had behaved honorably
in it, delivered what we said we would, and didn't favor CalArts-
people or abuse the relationship in any way. So that's how it was
settled in the end. For me it was one of the most flattering moments
in all my time at CalArts.

**The world of philanthropy is changing dramatically.
The data indicates that gifts under a million are decreasing
whereas gifts over twenty-five million are growing.
"The challenge in dealing with billionaires" as you've suggested
is that "the project or institution has to be spectacular enough
that it appeals to their ego. Plus, the best predictor of giving money is
that your family had money when you went to college—
and CalArts doesn't attract a wealthy student body on the whole –
in fact we're exceptionally poor. It's very hard to move a small,
non-financially-elite institution into the ego-satisfying role
that results in substantial giving."**

I guess that all smaller non-profits are caught in this the-rich-get-richer dilemma. What is happening is a centralization of wealth with a few wealthy institutions accumulating greater wealth from super rich individuals becoming richer. There are always exceptions. With colleges there is a hope out of loyalty from former graduates wanting to do something big for their institution. But generally it's quite scary. A donor who I won't name gave a large contribution to a larger college to build a new building and I said: "Why did you give it to them and not to us? You actually have more association with *CalArts*." And he replied: "Because if I build it at this place it'll be visible. If I build it at CalArts no one is going to see it." So we suffered from being small and somewhat out of sight in Valencia. Billionaires not interested in modest gifts anymore is a huge problem for philanthropy going forward. Because they have so much money they have to dispose of and because they need big-ego recognition—Lincoln Center, Harvard, or stuff that looks like it's the world's stage. What that means is either you have to be able to demonstrate that a particular program at your school is the best or nearly the best in the world and that it is on a world stage. Or you just give up on those people supporting your institution.

Silicon Valley, by the way, is mostly a bad influence at least for the arts. Because they tend to believe that entrepreneurship could cure anything. I had this trustee I really liked—a high-ranking Silicon Valley person. He had a lot of money but never gave because he was afraid he'd spend it on us and then lose it. He only wanted to invest money to start a business of CalArts. But I couldn't find an area in which

I could let him invest to start something that might support us and suit him. This kind of faith in entrepreneurship doesn't work very well for arts organizations because they cannot pretend to set up a business they're never going to maintain.

Investing money seems far easier than inventing a charitable vision the likes of Disney or Annenberg who gave much of their fortune to non-profit-organizations.

But even there they ended up locating their big enterprises at even bigger enterprises like USC or the University of Pennsylvania. Most of the ambition is about having to fall back on an existing structure of some sort whether it's a university or a kind of non-profit. And there again often the smaller institution is not in the position to take on the personal enterprise of somebody who's got a vision that is close to but not identical with that of the institution. It's hard and I think it's going to be even harder for them going forward. I think that if we don't have wealth distribution in fairer ways we're going to lose true civic culture that sustains democracy. We're losing it already because the rich are so rich they can buy the government or just get the government to pass what's convenient for them. Just look at the US tax reforms, which, in order to support the businesses of the privileged, are robbing the treasury of the United States. It actually means that the US takes out a trillion dollars more debt so that even more money can go into the hands of the superrich. That's basically robbing the state for their own benefit. When this happened during the progressive era in American history it really took a rising up of the population— a different kind of democratic populist movement—to turn the tide. But now the forces are even more unequal. So it's hard to see what's going to bring some change. There has to be an end in some way but it's hard to see what drives it if people can be so off the mark electing Trump, voting against their own interests in such fundamental ways. It's easier to imagine the end of democracy than it is to imagine the end of capitalism as it is currently practiced.

DEMAGOGY VERSUS DEMOCRACY

By opposing pluralism and diversity, contemporary US-politics is rapidly shifting towards isolationism, damaging international relations and democracy from within. How diverse or fragmented is America at present – might its achievements finally rule against its fate?

America has always been fragmented. It's always been against immigration, whether Irish, Italian, German, or Jewish immigration in the nineteenth century or twentieth century. Our country is run by people who were scorned when they came to the United States. What's held it together is the implicit or explicit promise that there's a place for everyone—that everyone could make his life better and more secure. Up to the 1970s the economy was able to keep that promise and grant space for immigrants to make a contribution. That was a reason to become an American. There also was a claim to equality that people weren't experiencing in their own countries. Though we never fully realized it at any point in our history it was an ideal you could share and see how it would include you. That ideal is at risk. But the reason for that is not diversity. It is the government doing far too less to facilitate that promise. The fact that we aren't delivering economically for people reduces a lot of the driving force that lets us incorporate diversity. The underlying problem is global finance. The power of international banks and of the global movement of capital is so enormous that governments really can't govern their own countries anymore. The market decides whether you have investment capital in your country or not. It's out of control of the presidents, out of control of the congress. Therefore, if government can't deliver something substantial to its population, if it can't attend to their social welfare, then it has to deliver something else: it creates an enemy for them and then delivers them from the enemy, whether the enemy is African-Americans, Latin Americans, or Mexican immigrants. That is what President Trump has done. He's turned the US into a kind of Darwinian world of survival of the fittest both domestically and between us and other countries. A world filled with enemies, whether ethnical, economic, or political. It's very striking in Trump's invective and treatment of

Mexican-Americans. By and large the people he's trying to get rid of are taking jobs that other people don't want. It's easy to say "The Mexicans are taking away people's jobs," but in fact it's not their presence taking away anything. It's the globalization of the economy and the transfer of skilled jobs to wherever the labor is cheapest. We've shared a culture all along with immigrants. They're even bringing us what we think of as traditional American values: family, hard work, religious faith. They're actually behaving more like the past-imagined USA for which many Trump supporters are mistakenly nostalgic.

If we could allow immigrants their fair opportunity they might actually help restore the values that people are busy thinking have disappeared from American society. We need to restore the economic structure that held us together. We need to find ourselves again. And we need to restore our ideals. The awful thing that President Trump does (though everything he does is awful): he's turned against those ideals. So far we have had aspirations (or, publicly declared aspirations) to live up to. Trump now publicly denigrates those aspirations. He's giving us nothing to be Americans over except having enemies.

How smart do you think Americans are to resist that kind of demagogy?

I think it's all too easy to confuse people. We always have the potential for an easy wrong answer—we're all weak. In the US it's probably more threatening than ever because we don't have as many counterbalances as we once had—social organizations where people could remind themselves of what's best in them that we required and that gave us hope: unions, churches, and artists communities. Real participation and being part of communities was a kind of resistance to the wrong conclusions. Right now these organizations are as weak as they've ever been except in certain isolated parts of the country—little towns in the South and the Midwest—where they still exist and we don't value them. There are fewer barriers to demagogy than in the past and the shock of the present is: we thought our government itself was a barrier, but it turns out it's not.

In many ways it comes down to having leaders who speak honestly to the best of what we are again and deliver a vision of what could be best for our country. I don't believe in the depth of violent emotions.

I'm even willing to extend this to the German people in the Nazi era. Under Nazi leadership it was as bad as the world has ever been. Now Germany is the world's great upholder of human rights and human decency. I'm sure there were many Germans who initially thought Hitler was a good idea until, at a certain point, it was too late for them to go back and there was no or little place left to resist. I still have to believe that at the end of the day, as in the case of Germany (even though it took intervention from the outside), people in America can rediscover their best own interests, that eventually they'll find out whether something is hurting them or helping them.

It's striking how little most Americans care about the cultures of other lands and how often they seem to believe that everyone in the world thinks and acts as they do, or worse, wants to. It's quite paradoxical: Americans do recognize and appreciate differences among cultures within the United States but are obviously reluctant to know about the cultures of other countries, to learn how those elsewhere think and act or react to something Americans do.

We suffer from living on something like an island cut off from the rest of the world. There was a time you had to go out of your way to make connections with it—when our economy was the strongest internationally. Everybody wanted to be us so it seemed. Although when the children of Marx were drinking Coca-Cola they only wanted some of our economic advantages. When I studied French in high school our teacher said: "All of you will go to France within the next ten years," and I thought: "Oh, spare me—we're not going to France! We'll be lucky if we make it to Minnesota." Because everything seemed so far away. Most Americans still don't have the reasons or resources to discover the bigger world, thus it's easy for them to imagine our situation as somehow better, even if it is much worse.
Meanwhile we're suffering from a relatively small group of people living in a bigger world and another class of people who have very little opportunity to be even aware of any bigger world at all. China may have the effect of forcing us to recognize that the rest of the world really exists. Because we are pretty clearly losing what we thought was our central place in the world economy. Part of the question that needs to be addressed is: to what extent do cultures survive on their

own weight and to what extent is culture in part shaped by economics? When you look at the kind of run-a-muck-capitalism that goes on in China right now it strongly resembles earlier periods in American history. Think of the robber and railway barons, people who undertook unimaginably large projects, created monopolies, and killed people who resisted their vision. Colonialism is abetted when the other country appears to need you more than you need them. And whoever is in the power position in that equation is in the position to abuse their power without even trying to. Because if you think you'll need their resources there's an urgency to it. If they would like your resources but don't think they need it it's not urgent from their part. The fact that the world's transactions have been underpinned by dollars has put the United States in an incredible position. But as we go deeper and deeper in dept it's not clear whether the Euro or the Chinese Renminbi might become the basis of the world's transactions. Should that happen much else would shift with it.

Talking about economic divides from an international perspective we should also take a closer look at America's social climate. According to sociologist Elizabeth Currid-Halkett, the economic and cultural elites in the US are so far removed from the day-to-day hardship of the middle- and lower-income classes that they may become unable to even imagine (let alone solve) the pervasive problems of their poorer fellow citizens. Americans used to believe "you should make up your own mind" and "do your own thing" rather than allow yourself to be overly influenced by other people and the flow of external events. No culture has been known to be as dedicated to fulfilling each individual's dream. But given the alienation and inequality between rich and poor one may ask how much there's actually left of what had once been called the American Dream?

It still persists—though as a dream with less and less underpinning reality. We have less social mobility now than many European countries. We were never great at it but certainly better than England. And now England—with its classes and society (if there ever was one) – has more social mobility than the United States. You cannot believe it's come to that. And yet right now you can hear it in the language of almost everyone in US leadership and government that they have

no idea of what's going on in the world. And if they know they pretend they don't.

Mobility, diversity, democracy—they provide the seed of innovation in any field. Most scientific breakthroughs and business reforms involve a person examining a situation differently—the right perspective can make a problem easy. At the same time different perspectives frighten those unable to trust thinking. Over the past thirty years you have worked into many directions to bring change to CalArts. More than anything you've pushed it towards diversity. Today CalArts is likely the most ethnically and economically diverse arts school in America with 40 to 60% students of color, 20% international students, and languages from all over the world that can be heard across campus. As you declared: "We need articulate voices who can talk to the rest of the society about what their experience is. We need it from every corner in order to make a democracy that hears everyone. And that means one has to be educated in those voices to be articulate and powerful, cut through the noise and be heard." Meanwhile, in contrast to that, a conservative billionaire administering US education propagates elitist schooling.

Elisabeth DeVos has no idea what she's doing: causing damage. Perhaps not always intentionally as we have some people in government who seem to intend to do damage. But hers is just total ignorance about what is. One of the paradoxes people at economically elite institutions are facing is that their institutions become machines for perpetuating the wealth of the wealthy. With the best intentions of the world to achieve diversity they, under the guise of meritocracy, are becoming factories that reproduce class difference. Once American education was an equalizer that gave you a chance of entry. Now that's by and large not any longer the case. I remember seeing this chart rating universities by how much they'd actually promote social mobility. If you took the twenty richest universities in the country, the ones you'd think could promote social mobility because they could afford to, none of them were promoting it. They were reinforcing class difference often without realizing it, taking the best of those who already had the most opportunity.

One thing I was deeply committed to at CalArts and held on to was *not* rewarding having had previous opportunity. I fought tooth and

nail for it *not* to become the case at CalArts and to make it really concrete. If you admit a student on the bases of how well he plays an instrument, a kid who's been able to afford a super music teacher for twelve years before coming to CalArts, it's obviously going to have much more developed skills than a kid who went to a public school, had a band leader teaching him music and to play an instrument. Therefore we fought to reward kids who had something interesting to say for themselves. Because we thought that's more important than to have better technique on your instrument. Right now America is totally in the grips of rewarding previous opportunity. We are so deeply in the grips of this inequality of great previous opportunity that it threatens everything good that America has ever been. We've always had great inequality. But the reality of possibility of opportunity and at least some efforts to make opportunity kept us on the track of doing better. And we had years when we did better.

Now we've created such an elite that we're almost guaranteed to do worse. When the history gets written we will find out that the super-wealthy were actually stifling the economy not building it. The big companies are so big that it's impossible for smaller ones to enter the economy. Some new "Snapchat" or whatever may appear and we might think: oh yes, smarts can still open a door. But in fact we've got a self-reinforcing, monopolistic system. Everything that Marx predicted about capitalism except the internet and what's happening with the international movement of capital has come true. Marx predicted the self-defeating excesses of capitalism. I fear we've almost guaranteed the decline of everything our country stood for. And I think our diversity is our best bet to remember what it was we started out to be.

What if diversity also added to the splitting of public opinion? Imagining America united in one voice at this point of time seems pretty impossible.

We never really had unity. What we had was possibility.

CalArts graduates, Los Angeles, 1978

And patriotism.

Patriotism, I think, was based on the possibility—on the fact that there was hope for something better. The truth is the greatest patriotism right now looks like it's from the super poor. Those who've lost everything else but hold on to their pride being an American. And we certainly have more patriotism among our immigrants than we have from the 10 percent of the richest people in the country. I see few signs of genuine patriotism there any longer. It's global capital—and their money is parked somewhere else.

Both diversity and patriotism need people who are willing to integrate.

By and large the immigrants have recognized the economic necessity of integration; they want the opportunity America could give. But when you refuse them the resources to integrate then you force them to fall back on their differences. We did much better in previous generations in actually providing resources to people to integrate.

Now we starve our school system, which is one source of integration. Our social communities and various organizations are weaker. We make it impossible for immigrants to become the Americans they want to be. People are smart, they know there are better jobs if they learn English. But you have to have an opportunity to learn English. You have to have a school system that teaches you. It feels like we got it all backwards. If we want to be a united country, we have to invest in making it possible for people to participate—as it happened in the past.

I know the case of Jewish immigrants quite well. The German Jews, who were already here, didn't like the Eastern European Jews. They thought they were low-class and were likely to encourage antisemitism. However, there was a kind of loyalty bred of religion in which, while they did not encourage immigration by and large, they did provide social services and tried to make it possible for Eastern Europeans to become as integrated. I think it is the story of one group after another helping those who came to start a new life. But that meant there would have to be some opportunity, so the people here had resources to help the people who newly arrived.

FROM ANOTHER WORLD

Your ancestors came to America from the old Lithuania with Vilnius at its center—a place of spiritual, cultural, and religious Jewish activity. Among those who fled Vilnius from pogroms or annihilation were luminaries such as Marc Chagall, Jascha Heifetz, Menachem Begin, Al Jolson, Louis B. Mayer, and Chaim Soutine. With their demise what had physically remained of the past was basically gone. Today there is a lot of thinking and writing about epigenetics. Do you believe—orfeel— that something of the human or spiritual condition of your forefathers from Lithuania has been passed on and is actually alive within you?

I do. Although I wouldn't describe it in exactly those terms. Because I don't know what the living circumstances of my forefathers would have been. I was raised in an enlightened Judaism, more ethical than anything else. And I like to think of my father as having been a real remnant of that kind of faith. Whether he got any strength from it or actually believed in God I don't know—he never talked about it. But he felt ethically bound to go to the synagogue—as an obligation to previous generations who had died for the right to be Jewish. He wasn't going to let down now that it was easy—he wasn't going to abandon his faith. I don't feel myself to be carrying on that tradition, I don't go to synagogue at all—maybe once in a blue moon. But I still feel myself to be Jewish.

My question aims at something more spiritual though.
Try to imagine old Jewish Lithuania as a song from the past
that's resonating within you, the descendant.

A lot of that song was actually about living up to rabbinical law. And most Jews from old Lithuania were farmers from farm towns—not from intellectual centers like Vilnius. When the Eastern European immigrants in Germany and Austria enjoyed their religious freedom, many of them subsequently left their Judaism behind but still lived according to a kind of ethical Judaism. I feel myself the inheritor of that eighteenth-century tradition, which is fulfilling your obligations to God by doing the right thing. The idea of one's own self spiritual

Members of the Lavine Family, Vilnius, 1900

improvement—of religious instincts passing through enlightenment language—is part of that inheritance. And it's still behind what I'm trying to do: believing in democracy, rooted in the fact that those liberal regimes granted freedom to the Jews and gave them a reason to care about the future.

**Do you feel a kind of soulful connection
to Jewish history, culture, places of origin and belief ?**

I searched for that connection when I taught American-Jewish literature—searched for a kind of remnant of a cultural and religious past of Judaism that I could believe in and connect with. In the end, I guess, it is mostly through music, the music my mother played as a pianist, I feel that in there is some of that inheritance and spirit.

**Immigrants with the name of Lavine, the majority of them
laborers and farmers from central Europe, entered Ellis Island
between 1870 and 1875, holding out for a better future.
The US Federal Census of 1940 lists your paternal grandparents,
Harry Lavine from Lithuania, born around 1882, and his spouse Sarah,
as citizens of Superior, Wisconsin. It seems likely they had entered the US
around 1900 and strengthened the foundations of the American branch
of your family.**

But why Wisconsin? I had always wondered how they got there—
until one day I saw these ads from the 1880s in the local history
museum: advertisements for jobs for thousands of people to work for
iron mines that had been discovered in nearby Minnesota. It was to
the center of this iron-ore area where the earliest of my relatives had
moved—after escaping waves of pogroms or being drafted in the
Russian army.

According to the family story, my great grandfather was a learned man.
On his way to America he had made it as far as Amsterdam, where
he broke a leg. While recovering, he supported himself by leading
services as a rabbi. Then he set out for Ellis Island, in the hold of
a wooden ship. When Hanukkah came, some of the passengers lit
candles. On the fifth night the ship's crew discovered the lights
and ordered them extinguished. As I was growing up, the fifth night
of Hanukkah was celebrated as the most important in my family.
That's when we children always received the best gifts.

My grandfather Harry, whom you mention, ran a seed and grain store.
My dad talked about delivering goods to clients on a horse and wagon
as he was growing up. While going through our home after my father
died, I found a piece of stationary from Harry's store from then. Harry
only spoke Yiddish. Grandma Sarah had some English, but it wasn't
very good. By the time I was mature enough to be interested in them
they were both very old people. I and my sisters did go visit them and
try to be good grandchildren. But because they didn't speak English,
it was all the responsibility to show some interest without any real
connection.
Sometimes my grandfather would pay us a nickel to kiss him when he
didn't really shave enough and we resisted the tickling that came with

the embrace. So probably he was trying to reach out warmly. But somehow both of them seemed like strangers out of a distant past—as if they almost didn't exist.

How did their Yiddish sound to you?

Appealing but also quite mysterious, as we weren't supposed to learn it. My mother had some Yiddish, too; my father had a fragmentary knowledge of it. It was the language they used when they didn't want us to understand what they were saying or meant to keep a secret.

What can you tell me about your mother's side and their origins?

Very little. My mother wasn't interested in anything connected to the past. I know there was pride in her great grandparents who had been quite successful, but it was never much talked about. Originally they came from Saint Petersburg, where they ran a tannery, I believe. Someday, somehow, they made it to America. When my mother's parents, Anna and Jacob, got married, they moved from Milwaukee to this little town called Sparta in Wisconsin.

In my formative years we'd go visit them and stay at their house quite frequently, as Melrose, the small town I grew up in, was close to Sparta, where Jake and Anna lived. I remember the living room where we used to sit, with the piano my mother used to play as a girl. Equally the paisley carpet I used to like for all the curves in the design, driving my toy cars around them. Anna, Jake, my mother, and I would often play bridge. Anna was a good, analytical player, who knew the rules and figured out what cards you had in your hand. Grandpa Jake played instinctively, his bids came out of the blue, although they often proved correct.

Jake had had a number of businesses that were or weren't successful until finally he ended up owning a bar right in Sparta—the only bar in town that didn't let prostitutes solicit, even though it was near a big military base that was active during WWII. Being a decent man really mattered to my grandfather. It didn't matter that he wasn't successful economically. Economic success was never a particularly important thing in my family—it was being decent. And Jake was clearly a kind, gentle man. He looked like Harry Truman, sometimes was even mistaken for him on the street. I remember entering his bar as a boy,

ordering a beer. Grandpa would get me a glass of root beer, hoping someone would tell me "You're too young to be in a bar!," so I could reply: "It's my grandpa's bar—of course I can be here...!" But it never occured.

About Anna it's been said that she was actually quite severe and that it was her treatment of my mother that left my mother with limited self-confidence. But I don't recall ever seeing anything that would affirm that impression. I remember both of my grandparents as warm and loving people. By the time I was in high school, when they were already frail Anna and Jake came to live with us in Superior—in a house that really wasn't big enough for two more people. My mother was quite cursed to inherit this responsibility—the whole burden of taking care of them. In fact it was a cause of great unhappiness for her. She would wake up in the middle of the night in order to roll grandma Anna over because at a certain point all of the muscles of Anna's body had begun to disappear. It was an endless care—with my mother being unhappy all the time and me not knowing what to do about it. I tried to shut it out but never could. I always imagined I'd have to take care of my mother in old age, too and dreaded the moment that would come, thinking: "You're are about to enter the world and then you end up rolling your mother over in bed at night." I just didn't want that as my future. And then it turned out my mother died quite young, at fifty-nine. So it never happened.

ALL AMERICAN

It was in the 1920s when sociologist Robert Park suggested
"that Jewish history be taught in the schools so that Americans can learn
what America is." Park argued that Jews were quintessentially American
in their energy and drive for achievement.
He also referred to Benjamin Franklin, whose values not only appealed
to Americans but Jews in Eastern Europe. Franklin's writings had been
translated into Yiddish around 1800 and were henceforth devoutly read
and discussed in Talmudic discourse fashion by young Jews in Russia
and Poland after their daily religious studies in yeshivas.
The actual kinship of Calvinism to Judaism made Jews welcome
in America, as it valued the bourgeois and market ethic and the classical
laissez-faire liberalism of Americans. Against this background Eastern
European Jews in the US have been able to become the better educated,
mostly middle-class, and, ultimately, the most affluent ethno-religious
group in the country. Does this resonate with your own family experience?

Not primarily. There was never a big emphasis on making a living
in my family. The focus was exclusively on my father being a doctor
and doctors being presented as a way of making a living. However,
the primary thing about it was that my father addressed people's
suffering—as opposed to others who focused on their own success.
I remember one day my best friend George and I walked past the
synagogue—it was in late September, about the time of Rosh Hashana,
right when the new car models appeared in the showrooms. And
George pointed out to me how people were proudly driving to services
in their new vehicles, showing off they had made it and that this was
part of the success in America. Well, our definition of success was
different: my father's family is almost a perfect immigrant story, where
the oldest daughter, aunt Elsie, went to work so that her brother,
my uncle Ben, could earn an undergraduate business degree and then
a job in a big department store in Chicago. Ben and Elsie contributed
money that helped their two younger brothers, Max and Israel
(my dad), go to medical school even though it wasn't very expensive.
The youngest aunt, Rose, went to school in library science. It was

a family investing in one another with an immigrant sense of we're in this—bonded—together. There was a deeply shared feeling of loyalty and solidarity.

How do you recollect your relatives getting together?

Frankly said, I remember it being such awful, boring evenings that I just hated. We would have everyone over for Thanksgiving or the Jewish holidays on Rosh Hashanah, Passover, or Yom Kippur. My mother would host the dinner. Though Elsie was the easiest to communicate with (probably because of her routine with customers) I still don't remember ever having had a serious conversation with her. Rose was always complaining about something. And Max was so silent that, except for slightly ironic one-liners, it's hard to remember him ever saying anything. The most humanly open of them was Ben, he was our favorite relative. But basically we all bored ourselves to death. Only one of the five siblings married at an age that was normal then to assume someone getting married. Elsie and Ben (who were twins, although they didn't look anything alike one another) stayed single. Max married in his sixties. My dad married at forty-eight. I never could explain why it came out that way except that they were all shy...

So your folks were rather quiet people?

Very quiet. A very introverted family. And so was I. From early on I never felt like I had anything particular to say. I spent my junior high school and high school years trying to find a place in the house where I could hide with a book. I would lock myself upstairs in the bathroom or somewhere else until my mother would find and interrupt me. There was a kind of withdrawing from the guilt of not being able to live up to demands—or what I felt were demands—from the world I was in. Perhaps that was typical for my family. A discomfort. A never-having-felt-totally-at-home-in-the-world.

Might the history of diaspora have played a role in this?

Perhaps at some deep level. But I mean we grew up in America—we had very little sense that we were anything but Americans. My father

was the only one in the family who didn't want the past to be forgotten. He wanted to pass it on in some way. Maybe because he was intensely aware of the threat of anti-Semitism. Part of his argument for being a doctor was that if you could cure people they'd come to you whatever your religion is. Becoming an academic meant being subject to subjective judgements or decisions and there anti-Semitism could play in. I don't remember my father ever telling a story about being exposed to anti-Semitism but he must have been to share that view of the world.

My mother had grown up with real awareness of anti-Semitism. As a schoolgirl she used to go to the library whenever the new copy of *The Dearborn Independent*, a weekly newspaper run by Henry Ford, would be delivered. It was a seriously anti-Semitic publication. My mother would cut out all the hostile articles then turn the damaged newspaper back in and pay for it. I don't know if she did this many times but the feeling of it was she did it with every issue. It's key in the story that she was open about returning the magazine. She was a pupil standing up for who she was and standing up for justice. I think we're all really proud of her for having done that.

What about yourself—have you ever been exposed to anti-Semitism?

There was this American Legion School Award in junior high school given to the most outstanding student. Teachers came to me and said: "*You* should have gotten it but it can't be given to someone Jewish." They made it sound like an apology, implying "We know *you* are the best, it's just that the rules are we can't give it to you." One of my sisters had the same experience—with the same feeling that it wasn't the teachers being anti-Semitic but rather the American Legion. So it never really felt like a damaging thing.

Being exposed to a certain degree of anti-Semitism and growing up in a family where everyone including yourself felt kind of isolated from the world seems pretty burdoning.

And yet I loved my family. There were bonds that created a sense of mutual support, intense connection, and responsibility. It wasn't really fun to get together but there was loyalty. And that's what's shaped me.

I felt I might not be worthy of being loved—I felt I'd gotten better than I deserved even in later years being president of CalArts (and even though I knew I saved the school and they were lucky to have me). But I never felt unloved.

As we're talking about it right now I feel this great warmth about my family, though I don't know where precisely it comes from. But I know they really cared.

KINDRED SPIRITS

Do you know of any secrets being withheld from you in your early years?

Basically we're not a family with much to hide. However, there's one mystery: we were still living in Melrose when it was floating around that my father might have had an affair with a nurse and that her kid, who was my age, might well be my father's illegitimate son. There never was a shred of evidence or anything, I don't even know why it was a suspicion and find it hard to believe it was really true. But it's possible that it's true and it goes with my sense that mother and father may have never really loved one another, living a kind of arranged marriage, trying to make the best of it.

How did they meet?

The first time they saw each other my mother was still in high school. Years later, when they actually got together my father had established a medical practice in Melrose, a town of five-hundred people in rural Wisconsin. The previous doctor then wanted to retire and was willing to sell my father his practice (over time instead of a lump payment, so my father could afford it). I imagine that my mother's parents living in nearby Sparta (which had almost no Jews) saw this good-looking, single Jewish doctor only twenty miles away and invited him to celebrate the Jewish holidays with them.

Your mother Harriet, a pianist, being thirty-eight, and Israel, your father, a medical doctor, being ten years her senior, were married in 1945: two people who were dissimilar in many ways. What did they have in common?

Both had a fundamental kindness about them and were capable of a lot of human concern. It showed in their faces although they demon-strated it in different ways. But it was genuine and not something they just talked about. It came with who they were. I really admire kindness in people. It represents something deeply human, caring, and compas-sionate that is much more powerful than the word itself conveys.

Harriet and Israel Lavine, Superior, late 1940s

Would you try to describe your father and mother for me?

My mother had very pretty, gentle, compassionate-looking features.
Pictures of her as a young woman show she also had the capacity
to be quite elegant. Over the years she gained weight, became a heavy
smoker, and developed a serious cough. When she finally gave up
smoking she gained more weight and was often disappointed in herself
for being unable to look too good dressed up because of it.
My father, although he was also a little overweight, carried it quite
well, as he was about six-feet tall and, if dressed a little sloppily,
looked fairly distinguished. As a young man he was quite hand-
some—tall and elegant, with a moustache. One can imagine that side
by side my parents must have been a romantic looking couple in their
earlier years.

Were they somewhat kindred spirits?

They were very different. My father, like his siblings, was a quiet man.
He loved being a doctor, mostly trading and giving advice based on his
medical experience. My mother was the inheritor of the twentieth-
century *Luftmensch* in Germany—those daughters or sons who never

thought of making a living, their families being prosperous enough they just devoted themselves to thinking. She felt trapped in Melrose and later in Superior—places where there was no outlet for the cultural part of hers. I remember her as both unhappy and fairly upset, shouting a lot of the time about various things. My father helped to create the problem by not having paid more attention to what she really needed: signs of love and appreciation. Whether it was an escape from a feeling of turmoil at home, of not wanting or not being able to live up to my mother's needs I don't know—but my father basically worked all the time. He had no boundaries. He'd say, he'd be home at six for dinner and would instead show up at seven or eight. At some point for that reason my mother gave up being a good cook, she couldn't count on him to be there punctually. When she died prematurely and we asked our father why they hadn't moved to a bigger city, he said he knew how to have a medical practice in Superior being in business with his brother—but that he hadn't known how to handle it in a place like Chicago. My father loved the town he grew up in and he loved the small-town life he lived with my mother. For her it was a deprivation.

**Your mother more than anything loved classical music.
With a degree from Northwestern University she intended to pursue
a career as pianist, aspiring to perform in grand concert halls
around the globe—until instead she found herself being a housewife,
raising three kids.**

And that frustrated her. She associated masterful performers with a grand life and a kind of aristocracy. From that perspective the people around her in Superior didn't seem very interesting. She did participate with the Girl Scouts with my sisters and with Hadassah, the Jewish women's organization. And she did those things quite well – my mother was smart. But I don't think they gave her much satisfaction. There was also the bias that connected classical music with upper classes. And then there was always that piano sitting in the living-room...

...which she would play late at night, all alone and crying, as if the world had passed her by... Why had she chosen motherhood over a career in classical music?

It was a combination of things. Starting with her family not having the money to back her up. A career in the arts is very difficult, if you don't have a natural backing in the beginning. Besides Anna, my grandmother, really hurt my mother's self-confidence. How I don't know, but a lot was attributed to her.

And yet, Anna and Jacob had mortgaged their house to give their daughter a musical education.

On one level they were clearly loving parents. But Anna was stubborn as was her daughter. Both didn't change their minds about things and that might have been part of their struggle. I remember a debate with my mother: she thought the blue racer, a snake, was poisonous. I knew it wasn't and showed it to her in the dictionary so she could read for herself. But she still wouldn't believe it. She could be quite difficult.

Having a career as a concert pianist can take a great amount of discipline, abdication, and hardship. Perhaps your mother's sadness, stubbornness, and despair was partly about having to live with her own limits and coming to grips with it.

It might have been. I don't know what the limits were in terms of her talent. The "myth" I grew up with was that she had the potential to have a career but just didn't have the opportunity when she left university. She had to immediately support herself (and at that point, as a woman in the United States, you could basically be a teacher or a secretary). Besides, piano playing on a concert level was mainly a man's field. Though I don't think that was it so much, but that she just didn't have anyone to guide her—to tell her that you really have to go for it, be practical, and figure out how to support yourself in order to make your way—just as we try to tell our students at CalArts. When finally she focused on piano the way my father focused on medicine, and when a career as a pianist didn't work out, she never quite found her way again.

Harriet Lavine, around 1945

Generally speaking, there wasn't much emphasis on having a good time in my family—the idea just didn't occur. At some level, I think, my mother always knew she was in the wrong place. She never really was at home in the world she lived in even though she could function in it well. And so she constantly hungered after something better, more beautiful, more romantic or, rich in the arts. We used to have these two etchings hanging on the wall at our home—one of Paris, the other of Central Park. To me they always stood for the other world, where she wanted to be. There things really happened. She and my father travelled to national parks and the like but I think she would have preferred to go to New York. They did that, too, but not much. And she never had a chance to travel in Europe even though my father could have afforded to do so.

So maybe your mother didn't quite know where she belonged except in music.

It was in music. But it also was in places. In the excitement of the city. Like Chicago, with a kind of social class. It also was having the free-dom—and the money—to do nice things. In some way she had the

misfortune of having married a man who didn't care about things at all—who just didn't want or need them. Whereas my mother had this attitude: "Maybe if I get this, life will be a little better..." Or: "If just that happened, life is going to change..." I know it used to hurt me when she would buy something (always something modest) and try to find happiness in it. But it became a complex in her mind. Samuel Johnson wrote somewhere that "The natural flight of the imagination is not from pleasure to pleasure but from hope to hope."

I wonder why it was so hard for your mother to accept that musical virtuosity and raising children don't go together well. Once you've made the decision to have a family you're carrying that responsibility, certainly for a number of years.

Even as a child I wanted to tell her that it was a waste to hope for things that weren't going to happen. That she needed to accept her situation. I remember my mother quite often crying. She also used to stay up late at night—I always had the feeling she just waited for the rest of us to go to sleep so that she would not have to take care of us. It's not that she didn't love us but she needed space for herself. And the only space she could get was late at night smoking cigarettes, watching *The Jack Parr Show*, a TV talk show. And once she got herself on this crazy schedule she was tired all the time. I remember we did a trip to Yellowstone National Park and while driving through this beautiful countryside, my mother, because she kept this awful schedule being up all night, was totally tired out and mostly sleeping. At some point, all of a sudden, she woke up, looked around and said: "Oh, how lovely it is!," only to instantly dose off again. I remember it with great love. She was annoying—but so dear. Sometimes I imitate her behavior knowing it's a mistake: when I've been through a period where I don't have much flexibility about how to spend my days I wake up in the middle of the night and read on the web for hours— just for the freedom to make my own choice.

I assume you're familiar with Virginia Woolf's Mrs. Dalloway. The movie adaption, among others, tells the story of a mother, who, feeling trapped in her 1950s suburban nuclear family, leaves everything behind without advance notice. The film atmospherically depicts what you're describing.

I've read the book but haven't seen the movie. My sisters tell me that I was the only one who had the capacity to cheer our mother up and make her laugh. I remember it as feeling a responsibility I didn't want—trying to make her a little happier. I didn't want it because I knew that no amount would ever be enough. We'd always end up at the beginning.

That's probably what created the tight, but ambivalent bond between you and her.

True. Although I believe the most formative thing in my life was fleeing from the pain of her situation. Or trying not to suffer the pain of feeling her suffering. Because that's what it really was. And though I don't have any proof of this, I do think my father probably lived the same experience: staying at the office in part because that was more tranquil and more satisfying than being at home facing his wife's unhappiness.

In a way this reflects a twentieth-century dilemma that gradually disappears as women are increasingly integrated into the workforce and taking over key responsibilities.

Absolutely. That post-war generation of women went through hell. During World War II they had a somewhat better role because their labor was needed. But afterwards there was this turn against them, this ideal of domesticity. I think all over America there were women dying in this climate of forced submission...

...with their children being exposed to it. Just like you— a son being subjected to his mother's dilemma.

I guess it was my mother who taught me about the pain of life. Because I saw it every day. It didn't have to be dramatic, it didn't have

to be wild suffering or disease or poverty—it seemed built into this nature of being alive.

Now that we've talked at greater length about your mother, tell me: how do you remember your father?

My father was living to make a difference in the world. And I could see he enjoyed gaining respect for doing it—respect for caring about people. Once I helped him clean out the records from his medical practice in Melrose and there were all these bills he never bothered to collect. Hundreds of thousands of dollars in bills from farmers who couldn't pay their debts (as life in Melrose was very seasonal). And we just threw them away. Why try collect a bill from someone who couldn't afford to pay for it? Working his way up from poverty my father had attained a lot. He'd really made a success out of his life although he thought there was no great tribute to him for being a doctor -- he simply loved what he was doing.

To feed his natural curiosity he received this periodical called *MD Magazine*, a publication about culture for physicians—an opening into a wider sphere through medicine from an era where physicians were still seen as wise and cultured. However most of all my father was interested in people. He never assumed that because a man wasn't educated he didn't know things worth knowing. He was genuinely interested about what people would think and do and say. For the same reason he loved the way Rembrandt had portrayed people: their faces, their wrinkles, their way of human life. In college I was reminded of this when I heard Abraham Heschel, a theologian who followed from Martin Buber, speak about a Rembrandt portrait of his mother. She had been quite an ugly person but you could see that the artist, in the way he captured her face, loved every line of it. And Heschel said that from looking at Rembrandt's portraits he'd really learned about love.

Like you, your father was fascinated by the human condition.

He taught me to believe that we are all basically living the same life, if only living other versions of it. Within certain limits other people's

experience has something to tell you. Because just like you they only have this one life to live. And my father liked to learn things from that perspective.

One day we were shopping in a department store, probably in Chicago, and while my mother was looking around my dad would walk to the clock repair shop and start to talk to the technician about the mechanism of watches. That stuck with me as a different kind of learning: understanding how things worked—things and people.

I also remember him saying on behalf of his patients that there was nothing wrong with 50 percent of them—they were just hurt and needed someone to talk to and therefore came to talk to him. Just like the many catholic nuns from the two hospitals in our town run by the churches of St. Mary's and St. Joseph's. If they went to the catholic doctors and revealed how sexually frustrated they were they feared the doctors would tell the priests. My dad wouldn't do that. Instead he said: "Of course you feel sexually frustrated. Sexuality is a natural part of life. You've made a commitment and you respect it—but with it comes the sacrifice."

That was at least a kind of consolation—expressing trust, respect, and understanding and giving the nuns the freedom to speak about their misery...

... knowing they weren't odd because this was human experience was comforting for them. Like my father, I believe we're all experiencing pretty much the same things. Not because we're good or bad, victim or offender, but because it's life that's happening and there's a fellowship of human suffering, as Janet, my wife, has written.

But let me tell you another story of my dad, as we talk about him: there was a competition at our school to sell magazine subscriptions and get points for doing so. With those points you could buy a telescope, a leather bag, or something. And I realized: it's doctor's offices I should go to because that's where they need lots of magazines, plus they won't say no to me because my father is a doctor too. That way I always sold the most subscriptions. (And I think that's where the fundraiser part in me began—some kind of realization that there were ways to do this.) Then, one day, I came home and had lost all the money. I didn't know how much it was, I hadn't counted it, but I was

desperate. My father was very calm and said: "Let's retrace your steps: when do you last remember having had the money?" We went through all the steps and suddenly it hit me that I had stuck the money under a lamp because I wanted these crinkled dollar bills to flatten out. It was all right there. And I just loved my father's calm way of thinking it through and helping me in this situation...

... assessing a problem in a composed and rational way; not getting agitated but trying to find a solution.

Exactly. I've always been split between this rationality from my father and the anxiety I inherited from my mother.

Would you say that you were equally attached to both of them?

For a long time I thought I was more attached to my father. What I didn't see was the extent to which he hadn't taken care of my mother. I didn't understand that this was also part of what you sign on for when you get married—that it's not enough taking for granted that the other one is there. So in more recent years my mother has come back to me very forcefully, and now I want to know about her. My father outlived my mother for twenty years. He was sixty-eight when she died, and lived to be ninety-three. I had twenty-five more years of my father—there was a living connection. While my mother (her life cut short by uterine cancer) just disappeared.

STRANGER TO LIFE

**Melrose, a small farm town in Wisconsin by the northern banks
of a Mississippi confluence, the Black River, is where you
were born in June 1947. Tell me about the landscape, the climate,
and the atmosphere of the region you grew up in...**

This was rolling hills and fields, a lot of sky, and nothing to obstruct
the view. Small farms everywhere, another barn along the way and
silos, all these silos, where people stored their grain—you couldn't
count them. Two blocks from our house began the cornfields.
Wherever you went from Melrose you were always going through farm
country. There are mild summers as Wisconsin is pretty far north
but serious winters. On a few occasions I helped my father carry
his medical bag through the snow going out to one of his patients.
To this day that landscape as it exists doesn't really attract me;
though I do love New England—looking down into the valleys,
seeing cultivated farms with their barns among the hills.

How do you recall the house you grew up in?

It was a two-story house at a street corner, with a porch and an empty
lot next door. There were trees and grass on the side of the building
and flowers planted around the periphery. My mother, though not
particularly a gardener, would take care of it. I remember the house
being quite dark inside, rather narrow and confining, with smallish
rooms. There was an upstairs, a central corridor with rooms on either
side. The kitchen with a door leading to the yard was on the back side.
One year a patient who couldn't pay my dad plowed the field behind
our house and planted corn for us. And when the corn matured the
farmer harvested it as the way my father got paid.

**How am I to picture life in this white, northwestern
American nest during the early post-war period?**

As a place that had no obvious appeal, being essentially lower middle-
class, with little to do except sports. Melrose was too small to have

a sense of neighborhood—the town itself was the neighborhood, the rest was the country. The implications of war were so far away from where we were I don't think it was ever discussed. If you lived in Melrose you were pretty cutoff from everything. We didn't have TV then and all I ever remember from the radio is dramas and music, not news. The world always felt like it was somewhere else. Life was focused on where we lived. Although that did have the benefit of encouraging a strong sense of equality among the inhabitants. My elementary school was one block from our house. I could wait until I'd hear the last bell ring and then run over to the classroom. My dad's office was in walking distance too. I would cut through the yards, stop at Viola Young's, who used to baby-sit for us and who always had a cookie for me, and then run over to visit him.

Do you have other memories from your early years?

By the time I was in elementary school I remember a carnival coming to town with rides and music and everything. I had just had eye surgery, had patches over my eyes, and needed to rest in darkness for a while. I felt deprived. And my dad said: "Tomorrow the first patch will come off and then we'll be over to the carnival and walk through it." But when we went there the rides were being taken down, unfortunately.

Why did you have to undergo eye surgery?

I tend to see double because of weak eye muscles. I could never hit a baseball because I would see two baseballs coming toward me. It would have been dumb luck had I ever hit it. In exchange for pitching the ball, so I could help them, I filled Coke bottles with water and brought them out to the kids playing baseball in the field.

You were trying to join them though being somewhat lonely.

I even played being a loner with my older sister. I was a nice little boy but feeling kind of isolated from other children around me. I don't remember ever going out to their farms or us inviting them to our home. Perhaps because they were all rather fun kids and I wasn't.

Trying to hit a baseball despite seeing double (summer camp), 1956

I remember a lot of fearfulness. I can't recall any time in which I felt
at one with the world around me. Or comfortable in the world. Except
when I was with my family. Many of the memories I have are about us
getting into the car and driving somewhere, doing trips together, going
places to national parks and the like.
I also remember the pleasure of going to LaCrosse or Sparta—places
much larger than Melrose where there were things to be seen. I guess
my mother was already instilling the excitement of the city in me.
Once you are in southern Wisconsin, Chicago is easy in car distance.
I recall the city's wide streets, fabulous store windows at Christmas
with model trains chugging around. I always loved little trains. One
Christmas, upon entering a jewelry store with my mother, I lost my
helium-filled balloon. The store had a double-height ceiling and was
so high that no one was able to reach the balloon. Some weeks later
in the mail was a letter from the store saying they knew that this was
lost property—and attached was the empty balloon. What a very differ-
ent world from today this had been.

Many of my earliest memories are pretty unhappy. I've repressed a lot
of my life—just pushed it out of my mind. Photographs and scrap-
books show me as a happy little boy. I have repressed good memories
as well as more painful ones for some reason. But for whatever it's

worth I can't watch movies where kids are threatened.
I guess in a way I was already afraid of the world as a child.

Probably because you were being bullied way back then.

I don't remember being bullied so much as being fearful. I remember
a classmate brushing back my hair to find "my horns." I also remember
some little kid telling me Jews had little horns since they were descen-
ded from the devil. There may have been aspects about anti-Semitism
in it although I don't remember feeling it that way. I also don't remem-
ber my parents ever calling it anti-Semitism, perhaps because this
would be a part of Wisconsin where you'd expect a rather folkloric
view of the world.

Did your parent's moral and ethical attitudes matter to you?

Yes, definitely. And they still do. If I imagine a problem I still see both
of them trying to help me solve it. My parents were very ethical people.
I never would suspect either of them of anything even slightly dis-
honest. Honesty was just always assumed in our family, that you'd be
ethical and sincere. Not always straightforward—like I wasn't com-
pletely straightforward with my mother's suffering. The only thing
I remember trying to get away with is hiding from my mother's
unhappiness.

**So one criteria of your upbringing, if I get it right,
was to internalize being good. Or even being better.
Did that somehow imply that the way you were
was never quite good enough?**

Absolutely accurate. And I still feel that about myself—that I'm never
quite good enough. We were not pushed to be successful—it simply
was assumed we'd get good grades and go to college. Both parents in
different ways were clearly there for us. The lesson of my father always
was you didn't have to be successful, you just had to try to do your
best. Part of it was his thinking that being a doctor, although he loved
it, was nothing special—that almost anyone could do it, that many
people did it better than him, but that it was still a wonderful thing to
do. When I was floundering in my academic career (my mother was

dead by then), my father's basic attitude was "if you are having trouble with your research it probably means you weren't meant to do it but meant to be doing something else." There was nothing like "well, then you're a big failure." Our parents were always proud of our successes but we didn't get criticized for not being successful. When things didn't go right I was never really afraid that they'd be wildly disappointed about it as long as they knew that I had done my best.

And that was hard enough.

That was hard enough, indeed. Because the trouble is "doing your best" is endless. In a way it might be better to be pushed to some clear level of success.

You were about ten years old when your parents moved from Melrose to Superior, a somewhat larger town close to the tip of Lake Superior, where your father joined his brother Max in his medical practice. What kind of change did this move bring about for you and the life of your family?

I don't remember the move being discussed with my sister and myself. That summer she and I were sent to camp. I suspect our parents needed some time for the move and wanted to get us out of the way. Initially it was a shock when we returned to a very different home in a different place. Very soon however I felt a kind of liberation. The world seemed to open up into something bigger in Superior. As I sit here I can almost physically feel the sense of the opening up of space.

In the beginning I thought that I was now going to be big and tough compared to those city kids. But of course I wasn't—I wasn't any different than I had ever been. But this is the first time I remember having friends—not many, but to some I resonated. It was a lightening up of my life. Also because there was a lightening up for my mother—though it wasn't perfect for her; she had been exposed to the best and her standards were high accordingly. On one hand there was the Duluth Symphony Orchestra. On the other it was a real comedown compared to hearing the Chicago Symphony as she had when going to college. But she could live out her fantasies through her kids—my sister playing horn, me playing trumpet in the Duluth Junior

Symphony. It was during this period I became consciously aware of my mother's searching for something she was never going to find.

She took you to the opera, to concerts and museums, ensuring you'd learn about the arts. Did this actually meet with your own interests and needs?

Yes. We would travel to Minneapolis for the Metropolitan Opera, to visit the Walker Arts Center, and go to the new Guthrie Theater. I grew up assuming that it was in the arts I would find answers, particularly in literature but also in music. Because otherwise life to me seemed to be a problem. As a kid I read nearly all of the great canonical masterpieces—when I was much too young for them and without any idea what they were all about. I read *War and Peace* at fourteen. As I couldn't keep track of all the multiple names of the Russian characters I found a kind of graphic-novel version based on the movie with Henry Fonda and Audrey Hepburn at the library, so I could follow the many actions in it. *War and Peace* was the book that spoke to me most. It was almost perfect for me because all the characters are a little lost. They sometimes seem to be their own opposites: behind heroism there's non-heroism, behind intellectualism there's non-intellectualism—nobody is really sure what they're doing or what they're supposed to be doing. I still read *War and Peace* every decade or so, and it still seems to me right up there with Shakespeare as the best that literature has to offer.

Was it all fiction and philosophy you read or where there also non-fiction books—works that showed you what to do with your life or how it could be?

There was a series of landmark biographies of great men for children— once in a while of a woman, such as Marie Curie and Elizabeth Griscom Ross. That did have an impact on me as I was wondering how something special could be done or achieved in this world. In books I thought I was going to find answers, especially about who I might become under their influence. I didn't grow up in a very visual culture. It was words and music for my mother and people for my father. But I did put art in the same category that somehow their influence was going to turn me into the person who'd understand

what life was about. In the Walker Arts Center in Minneapolis for example, when it still used to be an all-purpose museum, there was a Qing dynasty jade mountain on display—the largest piece of carved jade in the United States—depicting a gathering of scholars celebrating the Spring Purification Festival alongside a stream. I had no idea what the story was but was thrilled with the illusion of deep caverns, winding streams, and pavilions, all appearing of vast scale way beyond the dimension of the sculpture. That was a real discovery of the magic of the visual arts for me—an introduction to the idea that there could be a kind of wonder—a kind of thrill.

The arts have always had a stronger impact on you than religion. But you have been introduced to some Jewish rituals and traditions, haven't you?

They played a role at home but I never particularly liked them nor did they mean much to me, except for the Coming out of Egypt in the Passover Seder. Lighting candles on Friday evening was what my mother did, although I knew she thought it was silly as there was no God to light candles for. On Jewish holidays she'd prepare traditional Jewish dishes, otherwise she was a pragmatic cook. My father kept up some traditions because his father did so. It was keeping up the side. Not for the neighbors or anything you might read in a Jewish novel or the like—we didn't do it for anyone else to see. We'd celebrate Hanukkah, Passover, or Yom Kippur—but it was always more a this-is-what-you-should-do-thing than that we truly believed in it.

Like rituals without meaning?

Like rituals that meant something for earlier generations and were practiced in loyalty to one's predecessors—without a direct connection to God but as an affirmation of your connection to the Jewish people.

An act of solidarity.

Precisely. In the same way I was expected to go to synagogue on Friday nights—in part because there were not many Jews in Superior; and technically you have to have ten men there in order to have a minion.

Hadn't there been two synagogues in Superior?

Yes, but there were not enough men in either of them to be certain
of a minion. So after my Bar Mitzvah at thirteen, I was asked to par-
ticipate so that other people could have their Friday night. On one
hand I resented it because that was the time when things happened
in high school, when kids went out to have fun. On the other hand
I liked it because I could avoid all those basketball and football games
that my classmates were going to do. Eventually it was made much
better by George Relles, my closest friend, because we'd walk to
synagogue and back talking, discussing how our lives could possibly
mean anything. Sometimes we would walk the ten blocks to synagogue
and back twice so we could keep talking.

Did Superior have a good rabbi?

George's father, Rabbi Relles. He was from Poland originally and
spoke Yiddish but in synagogue he spoke English with a heavy accent,
so that you couldn't understand parts of what he said. Rabbi Relles
had been a prisoner of war in Italy before he came to the United
States. He didn't give fancy sermons and he wasn't a good cantor.
But to this day I'd prefer him over any other rabbi because he wasn't
entertaining, he wasn't trying to persuade or something—instead
he cared. He was there for anyone who had troubles, needed help
or advice, and he visited sick people. Like a spiritual doctor, in a way,
though being a rabbi, he was doing what my father did. However,
at a certain point the Jewish community turned against him and
brought a young rabbi in—the usual more promising future. Maybe
it was just because of his age, maybe because he wasn't very articulate
and didn't sing very well. As a child I didn't encounter very many
things that struck me as unjust. But I remember thinking how wrong
it was to ignore that Rabbi Relles was doing the real thing: helping
people who were in need of it.

I guess it was him who also advised you for your Bar Mitzvah?

Me and George and everyone else—thirteen of us in my class, half
of them girls who were going through their Bat Mitzvahs then. There

were a hundred Jewish families in Superior at that point—but already it seemed as if the Jewish community was composed mostly of old people.

Can you recall which parts of the Torah were chosen for you to read?

Pretty much everything from the Friday night and the Saturday morning service. Rabbi Relles liked the fact that I was a bright kid and it was assumed I would manage to get through all of it. I took me about a year to learn to say the prayers—without understanding their actual meaning. But the biggest problem was that I didn't know where my voice would come out when I opened my mouth to sing because thirteen is when my voice started to change. For a little while I took singing lessons with a teacher who lived across the street. But in the end I decided to choose my old voice, the higher one, as it was more familiar to me.

Did the ritual itself actually mean anything to you?

The only time in my life I prayed I was praying to make it through that ceremony. And all I remember is being afraid of not remembering it all. Although the moment when I was called up to read out of the Torah—out of the scroll—did feel special, as if I was actually entering some version of manhood. You're up there with the other men, the rabbi showing with the pointer where the passage was you were to chant. However (because the Torah does not include any vowels) it was actually reading it off a sheet that *does* have the vowels included. So it's all a little fabricated. And he didn't teach us the meaning of the prayers... It didn't feel hypocritical but more like it was something you just did—being asked to act out being Jewish while feeling Jewish but without feeling any faith along with it, except when they spoke of mercy. Three, maybe four years later I became both more skeptical and more hungry for meaning.

**Do you recall Superior's public climate in a time when
moral repression, racism, McCarthyism, and the Korean war
were shaping the American mental landscape?**

> Superior was an economically depressed area then. Kind of poor
> and ragged with streets being in disrepair, many houses needing paint,
> a lot of people just getting by. There wasn't anything to live up to
> in a way, we were pretty cut off from what was happening.
> The Korean war? I remember George and I were joking about these
> military ads on television: "You can sleep easy because the National
> Guard is awake...!" I mean who would have bothered to bomb us,
> who would even know we existed? Nevertheless, I do recall being
> exposed to a sense that for many soldiers war was something great.
> That the camaraderie and mutual suffering was more satisfying than
> anything in the world. So there must have been a taste of what was
> going on politically. But McCarthyism didn't reach to where we were
> at least not in a way we discussed in our family. Our main connection
> to the outside world was Russian refugees who would show up begging
> by the door. Besides we had relatives somewhere behind the Iron
> Curtain to whom my parents sent care packages. Once in a while
> a letter would arrive, suggesting someone from the wider family was
> still alive over there. Otherwise we were a very uniformed population
> in Superior, basically German, Polish, Scandinavian and a few Eastern
> European Americanized Jews. It was as if we were living in an earlier
> century. I knew no African Americans, no native Indians, no Latinos.
> *Life* or *Look* magazine were the windows to the world.

**With John F. Kennedy elected president in 1960 a new era
was about to begin—socially, culturally, politically.
Did you have any sense about that as a kid?**

> Not then. My family supported Barry Goldwater (who was super
> conservative) because he had a Jewish background—although in
> general my parents were good democrats. The civil rights movement
> was already heating up nationally but for us it wasn't on the map
> because we were an almost entirely white community—or at least
> seemed to be. I remember *To Kill a Mockingbird* as a powerful early
> read—because of the lawyer's struggle for justice and his belief that it
> could be achieved. Justice was important to me, a sense that everybody

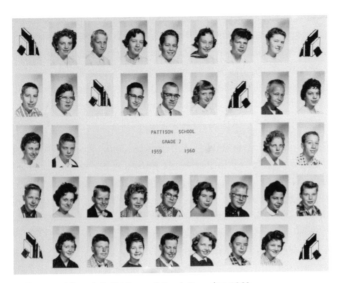

2nd row, 3rd from left, Pattinson School, Superior, 1960

ought to have equivalent rights and means. However, I was strangely
oblivious to the fact that in Superior a lot of people had less than us.
I didn't realize my mother was handing down used clothes to George
(as the community didn't pay the Rabbi very well). Our friend Russel
Wusznen was really poor; we knew his father sold coffee out of the
back of his car. But I didn't understand that this translated into severe
poverty. Although a doctor was a prosperous member of the commu-
nity I guess we just never felt better than anybody else. My father
enforced this attitude by telling us that anybody could be a doctor:
"If you can fix a car you can be a doctor too. It's just about the same
level of complexity." In a similar way he distanced himself from
ownership: "If you own things you only think you own them—because
they actually own *you!*" Somehow my father's ways must have turned
me into a premature socialist. My father was a kind, calm gentleman
of deep generosity. And yet it wasn't until college that I became more
politically aware and brought political debate home with me.

**As the new decade—the 1960s—began, America saw
an unexpected momentum in the arts and entertainment industry
with movies like *West Side Story, Judgement at Nuremberg, The Misfits,
Lolita, or Breakfast at Tiffany's*. Pop art and music entered
the public sphere as a mass phenomenon epitomizing the American.
For you it was the time of puberty. Was it frightening, was it exciting
to feel being succumbed to such a change?**

It was exciting *and* frightening. I remember lots of daydreaming,
sexual daydreaming and fantasizing. Watching TV at one point was
a lot about watching pretty girls—having a knee appear or someone
in a bathing suit in surfer movies. Everything became sexualized for
a long time. Still is in some ways. But I was very shy—about others,
about myself. I didn't hang out, I never went out on a date. My friend
Nick Schweitzer had a very pretty girlfriend—I was so envious of him
I always thought I'd be a much better boyfriend for her. But I didn't
have a clue how to attract a girl. So much compounded my fundamen-
tal loneliness. Even creativity seemed far away. It would never have
occurred to me that someone could make art in Superior. Art was
something that existed in Europe, in New York, or San Francisco.
That it could happen where we were seemed inconceivable. The fact
that I was raised with a kind of scorn of popular culture didn't make
it easier. Movies were not a big part of my life then. There were only
two movie theaters in Superior that one could get to on foot; one of
them seemed to show the same Disney movies for months at a time.
Once in a while there was a Western that raised the issue of courage
and heroism. But I don't think *Judgement at Nuremberg* or *Breakfast
at Tiffany's* would have ever made it to our town. It was many years
later that I got to see such films. As for music, I secretly liked pop
but bought jazz records and classic disks. Probably because I was sort
of prematurely aspirant to what seemed like a finer life—again in some
way my mother's fantasy. If something was deeply moving in classical
music it was okay because that didn't make you cry but lifted you
to another sphere. Beyond that I rejected a lot as kind of vulgar
sentimentality.

COMING OF AGE

**If we jump ahead in time, it's clear that at a later point in your life
you're going to have this intellectual awakening—all of a sudden
there is a boost of will, a lot of power, strength, and energy that had been
withheld up to that point. Was there anyone to help you come to grips
with yourself in your early, lonely years?**

There wasn't anyone who showed me the way. In junior high school
I came across a book recommending the one-hundred books you
should read: *The New Lifetime Reading Plan* by Clifton Fadiman.
For a longtime I worked my way through this canon, reading works
like Plato's *Politics*—without having a clue. No one had taught me
how to really think, unfortunately.

Who taught you how to really live and feel?

Feeling was the problem. Feeling's always been associated with
unhappiness. Part of it was seeing my mother frequently in tears.
And like my dad I've always been a big crier. I can be caught by huge
waves of sentimentality and cry at a *Reach Out and Touch Someone*
AT&T-telephone ad. Therefore, it was rather about trying to get
beyond feeling. In a way I had to tell myself my feelings didn't really
matter. That there was a truth beyond them and if I could think my
way through my situation, rationalize and control it, I'd also get rid
of my feelings.
Way in the future, when I started to listen to opera, I rejected all music
that was massive feeling. Deliberately. I'd listen only to works of
Mozart or Verdi or *Wozzeck* by Alban Berg. Until one day, by the end
of my first year at CalArts, there was a kind of awakening: I had been
working very hard, was utterly tired, and lots of emotion from every-
thing was pent up in me, when all of a sudden *Madame Butterfly*
came on the car radio, the Metropolitan Opera playing. It was like
a revelation—so beautiful I just started to cry. Suddenly I understood
why people listened to these operas: in a way they freed you to let go.
And of course, I'd love this!

**How about pop music, of which you said earlier
you liked it only secretly in younger years?**

I could get emotional over simple pop songs too. But in a way they had too much emotion for me. Because the trick was to get beyond emotion to understand anything. Even though I was taken by musicals like *South Pacific, Carousel,* or *Oklahoma* (because the songs would always move me), I rejected Broadway music out of hand as vulgar entertainment. One of the gifts of my adult life has been learning that there are powerful things in popular entertainment. I carry around a "high-culture-versus-popular-culture" prejudice. But intellectually I no longer believe it. In fact, an objection I had to CalArts in later years is that parts of it were too anti-popular culture. Because I no longer bought that as the way you'd embrace the world and understand it. But back in junior high school and high school it was all about holding emotion at bay, being in a world full of emotion though trying not to have it. At the end of the day I was overwhelmed with emotion—with my mother's sadness at the heart of it.

**So it was her distress that dumped your lightness
and desires?**

I think so.

How did you deal with that?

By my escape into books—into storytelling where the people weren't real. The artificial emotion was my substitute: if I attached it to a literary work it was ok to feel it. Because it couldn't overwhelm me. Even if I cried it didn't really matter—it was just a book or just a story. All of this goes back to my feeling that life really didn't mean anything—that there was just a deep hole at the bottom of everything. And that if you got too close to fully taking that in you'd be forever unhappy, you just couldn't live...

**Did you have any idea about yourself in those days—
about what kind of person you were or wanted to be?**

I wanted to be an intellectual, to understand things that were beyond me. I wanted to be able to think. Because while trying to read Hegel

and other serious philosophers at an early age I was aware I couldn't. Becoming an intellectual to me reflected being a writer—although I didn't particularly like writing. But I aspired to be a columnist; someone who had so much trust in his own perceptions of the world that he could write a daily column about whatever was before him that day. Not that I could *actually* do it but being able to respond directly to a phenomenon seemed the ideal occupation—that's what I would have liked to do. It was this phase when George, Nick, and I would go see things that seemed exotic; like a curling tournament—an odd and rarely performed kind of winter sport. We thought: "Let's see what that is ...," associating existentialism with opening up to life and seeing where this would lead.

What did courage mean to you in your youth and early adulthood?

I always felt like I was a coward. Largely because of boys' sporting things. I didn't want to crawl out on a branch, I didn't want to be physical in the world. I was afraid of getting hurt. As much as I always liked the idea of having the courage to have adventures, I was aware of *not* having the courage actually. I always worried that, given a hard choice, I wouldn't have the guts to make the right moral decision.

What was it you gained in terms of maturing from reading all those books?

I don't think I gained very much. Probably 80 percent of it was pure escapism. Reading was a way of killing time for me. Though there was always the chance that I'd discover something. But I don't think I did. Except for creating a lifelong habit of reading. My sisters and I would even read the writing on cereal boxes—as a kind of automatic reaction. Picking up a book is still my standard position. We all do in my family. I think what I was getting out of literature was a kind of experimenting in high culture.

Do you remember any significant moments in high culture other than in literature during your early years?

Yes. And they are really distinctive. I remember seeing a version of *As You Like It* at the Guthrie Theater, a new stage company that

started in Minneapolis when I went to junior high school. It became one of America's best theaters for many years. The play I saw, set in the American south, was so delicately staged that it is still with me as an amazing moment of discovery about the facts of life. There was a moment when just a character was rhapsodizing about being at peace with nature, his companions return carrying a deer they have killed for dinner. And the action just stopped—revelatory moment – only to begin again with nervous laughter.

An equally significant moment was seeing Alain Resnais's *Hiroshima, Mon Amour*, a film different from anything I had ever seen. The impact it had for me was not about the literal content—it was something about the tone of the movie, about two people being lost in time and the world's events going on around them. I think I recognized the feeling of not knowing and not belonging where you were. The feeling of awful things being out there and you were in them somewhere. It was similar to hearing Bob Dylan for the first time. I was in eighth grade and had no idea what he was singing about, I couldn't even understand the words for the most part, but it just felt as if it was true. I was hungry for answers in my early years, living in the vision of the world as a dark place where you suffered through your days and where your dreams didn't come true. I was hungry for something that would explain to me the meaning of life. But I never really felt I understood.

Somehow it seems to me that as a young man you were trapped in your life waiting to break free.

I always wanted to get out! And again this goes back to my mother. My going to Stanford meant she could visit San Francisco. Travelling clearly made her happy. In a way I should be quite bitter about my father because one thing he could have obviously given my mother was trips out of her usual frame in order to give her...

...a kind of life injection.

Exactly. And it wasn't that expensive. My dad was making a good living, he wasn't tight. He always had a little fear because he was born in the Depression so he didn't spend money—but he also knew he didn't have to hoard it.

Perhaps both of your parents were rather careful with their spending in order to facilitate a good education for all of their children.

Very true.

It seems that with attending high school you were suddenly energized: taking classes in speech and rhetoric, collecting money for good causes, involving yourself in artsy and intellectual activities, performing in the symphony, playing chess, joining student conferences, clubs, and societies. When the seniors rated their classmates then they voted you as being "teacher's pet" and "most studious." What was it that urged you to excel and compete?

I did what I was supposed to do as one of the smart kids. It's disappointing to say this but that was the main reason. I joined a lot of things without being attached to them passionately: the literary activities played into my desire of wanting to be a writer or intellectual but that was merely a fulfillment of a fantasy. I was interested in chess but could never really make my way into its full complexity. Playing trumpet in an orchestra was more what my mother wanted me to do. Performing always made me nervous. Basically I was worried I would play the wrong notes—also in terms of competitiveness because Nick Schweitzer, my friendly enemy, played the trumpet too. In the end doing all these things was about getting into a good college.

So it was mainly opportunism?

Elements of it. I guess I was learning how to persuade people to let me do what I wanted to do. But I never felt exceptional at any of the things I did. It's interesting I wanted to achieve—because I always felt that others were better than me. Nick and I later went to our Harvard interview together—and Harvard was the only place I really wanted to go. I remember the interviewer saying: "We can only take one of you two, which one should it be?" And I—already having a sense of doing the counterintuitive thing—said: "Nick is the smarter one, you should take him." And Nick said: "True." And so they took *him*! I remember how puzzled I was they didn't take *me*—for having been so generous to offer Nick. It seemed obvious you should take the person responding generously.

Jets Sponsor
Science Fair

A cloud chamber and an extensive study of toxic
effects of chloral hydrate and ethyl alcohol took top
honors in the science fair sponsored last week by
the Jets Club of Superior Central High School.

The cloud chamber was the work of William
Carlson, and the chloral hydrate study was made by
Thomas Ross. Both are juniors.

Placing behind Carlson in the physical science
division was Fred Seguin, who demonstrated the
oscilloscope he made to test his radio equipment.

Honorable mentions in the same field went to
Kathleen Marg, with a plastics display; Thomas
Walsh, who exhibited a computer; Ronald Pete, who
presented a mathematics demonstration; Daniel
Little, who made a telescope, and Gayle Bender,
who charted the sub-surface structure of the earth.

Sue Livermore took second place in the bio-
logical division with a detailed explanation of cancer
cell reproduction. Honorable mention in the division
went to Steven Lavine, who created a moon garden.

Exhibits of club members were judged by Prof.
E. H. Schrieber, chairman of the Superior State
College physics department; Dr. Joseph W. Horton,
associate professor of chemistry at the college, and
Miss Lillian Olson, Superior public schools system
art consultant.

A MOON GARDEN was created by Steven Lavine, who explains his
project to Richard Seguin, 13, son of Mr. and Mrs. Fred Seguin, 1708
Hughitt Ave. The display features plants growing under reduced pres-
sure to simulate conditions on the moon.

Creating a Moon Garden (Jets Sponsor Science Fair), Superior, 1963

But Nick had the chutzpah.

To me it seemed like they had missed the point.

**October 1964. Upon launching a monthly student literary magazine
you declared: "This is important! Because the new respect for intelligence,
which is slowly spreading through this land, spurred by technological
advances, has not included the arts. A magazine such as the one
the Writer's Club proposes will help to do this." Sounds pretty determined
and almost like a prologue to your professional future, which would
be supporting aspiring artists to have a career.**

I don't remember ever having said that and I don't think I knew
enough in 1964 to say that there was a new respect for intelligence
unless it was a response to the Kennedy era. I must have picked
that up some place—maybe my mother helped me write it.

**Your words seem ambitious but reasonable enough to gain public attention
for a literary magazine.**

Though retrospectively that language and that argument doesn't sound
familiar to me. I think I knew what people wanted to hear if they

were going to let us do this. However, what I really wanted was
to be a writer myself—an artist! The idea of an artist to me was just –
my God!—another kind of creature altogether. It always was a shock
to me when I met an artist who turned out to live in the same world
I lived in (which I never really thought would be the case). Whereas
when I tried to write literarily, I found myself adopting an existential
tone and content that wasn't really me. I couldn't shake off this voice
because it did convey the meaninglessness of life and my sense of pain.
It made me imitate somebody else instead of saying what I really meant.
I think I already knew I wasn't going to be a writer, at least not prima-
rily. I'd so loaded up the idea what art was or ought to be that I'd
intimidated myself out of it. Contrary to that I enjoyed writing
eight-minute speeches (something I had done to take part in state-wide
speech contests). Because there I didn't have the burden of having to
be profound or having to create; I didn't have to come from any place
of inspiration. These speeches were purely rhetorical—about argumen-
tation and the act of persuasion; not in the category of art but in the
category of thought, justice, or generosity. It was about writing
to get a job done. And that I liked.

**1965. The US was seized by Beatlemania. Martin Luther King received
the Nobel Peace Prize. Activists of the civil rights movement were
murdered. The first student marches against the war in Vietnam took place.
And Bob Dylan, a relative of yours, released his song The Times They Are
A-Changin'. It must have seemed like a calling to you, when he chanted:**

Come writers and critics
Who prophesize with your pen
And keep your eyes wide
The chance won't come again
And don't speak too soon
For the wheel's still in spin
And there's no telling who that it's namin'
For the loser now will be later to win

For the times they are a-changin'.

I loved this song from the moment I heard it—though I'm not sure
I really understood its lyrics; but it just took hold of me. And I'd make

myself ok about not getting into Harvard but instead going to San
Francisco where Hippie and Beatnik culture would be: "I'm going
to be part of it, sit in cafés and have serious conversations about what's
happening in this world!" Because that's how I wanted to live back
then. It wasn't something you could actually do in Superior, Wiscon-
sin—or at least it didn't feel as if you could do it there.

**Although photos of you suggest a pretty well-dressed, rather
conservative-looking young man: suit, black tie, polished shoes,
and not a hint of revolutionary demeanor—that's how you arrived
at Stanford University where you had chosen to study ...**

...without knowing anything about it. In those days the course cata-
logues didn't have pictures and stuff, just texts, so I didn't have a clue
what Stanford was like or even *where* it was. When the bus that had
picked us up at San Francisco airport turned towards Palo Alto
I stopped the driver and said: "I'm on the wrong bus! I'm going to
Stanford—in San Francisco!" And the driver said: "No, no, stay right
here—it's in Palo Alto."
I remember getting to campus feeling just awful and crying that this
was where I'd ended up: Because it looked like a country club! It was
so depressing! And I was *so* disappointed. I couldn't believe it. And
then there was no public transportation between Stanford and San
Francisco. Some students had cars, I didn't, and it never occurred
to me to buy one. So I had to commute by hitchhiking or getting a ride
with someone else. I remember thinking "real life is not lived here
at Stanford."

But then you thought twice.

Eventually I was wise enough to realize that actually I was in pretty
much the right place. Harvard would have been terrible—these
students who came from prep-school backgrounds on the East Coast
would have just intimidated me. I don't think I would have performed
very well. Stanford then was quite different from what it is today.
It had a lot of apparently quite ordinary students—but it was also
an interesting place. Upon registration we were asked to read *Catcher
in the Rye, Lord of the Flies*, and *Invisible Man* by Ralph Ellison.

Of all the three only *Invisible Man* (about a socially segregated black American) seemed exceptional to me. I went to the seminar and H. Bruce Franklin, the teacher, said: "You can forget about *Catcher in the Rye* or *Lord of the Flies* but *Invisible Man* is a great novel, it's possibly the greatest of all African-American novels." Hearing the teacher say that was like a liberation to me. It was so important because I had felt the same way about the three books. For the first time I sensed that my independent judgement had proved accurate.

And so you gradually got accustomed to the country club.

Even more so when I met Larry Friedlander because he taught me how to read. Friedlander was a wonderful teacher: a bright, gay, poetic person who read with delicateness and great subtlety. He would do a line-by-line-analysis of a text, talk about its metaphors and their meaning. He also introduced me to the works of Thomas Mann. Friedlander knew how to open up literature in its complexity. No one had ever told me what happened when you read besides reading the story: you'd hear the language, reading it out loud. I remember going home and feeling like a different human being. It was such a gift after all those years.

In second semester, H. Bruce Franklin returned. Franklin was the faculty member who was most engaged in anti-Vietnam-war activity. One day he'd be lecturing about the war, the other about literature, trying to enlighten us as to how literature and the outside world related. Franklin was rigorous. His approach was entirely the opposite of what Friedlander had taught us only months before. Whereas Friedlander wanted us to see the poetic in one's reading, what ruled for Franklin was the power of logical reasoning. Everything in your class paper had to be totally logical. There could be no logic connectives—no "thus," "but," or "however." If you used any kind of connectives—things that suggested logic—Franklin would cross off the whole sentence. He'd also cross off any sentence in which you made grammatical errors, spelling, or typo mistakes. And then he'd grade your paper on what was left, so you'd get D's and F's. And it was fabulous – like a different kind of learning how to think. Franklin and Friedlander were the most important teachers I had as an undergraduate.

I remember the excitement when I'd go home. I must have been impossible because I felt like at last I could think.

In a way you were taking to heart the mission of Phi Beta Kappa, the nation's oldest academic honor society you had been affiliated with: "Love of learning is the guide of life."

Even though I wasn't happy at Stanford. But I was very fortunate with my teachers. There was a third one quite outstanding. His name escapes me, but I liked him very much. He taught history of Western civilization. Although a subject I loved, I remember saying hardly a word for the whole first semester. I was so shy, so intimidated. Then – I don't know what came over me—I told myself, "You have to stop this, you've got to participate." I read way ahead, about the next three weeks of the material. And then I started talking and never stopped again—like a release into the world. It was with him that I gained the confidence to say what I thought about what I was reading. This teacher would also have us over to his apartment to talk, which was exactly what I'd come to college for. He was himself a medievalist, an expert on monasticism, a bachelor, and, as I think about it, probably gay, like Friedlander. I was afraid he'd find out how little I really knew and that he wouldn't want to talk to me anymore. And so—I'm ashamed of myself as I remember it—I started to fake. I learned to pretend I'd read things I hadn't yet read such as *Ulysses*. I learned to infer what the idea should be even though I hadn't gotten it from reading. But the truth is eventually it turned out to be a great preparation for being CalArts president. Because I always had to deal with people who knew more about what they were talking about than I did and yet I had to project a sense of my authority.

If you took such pleasure in studying and learning at Stanford why were you still unhappy?

Because I didn't know how to date. I was shy and most of the students who became friends actually intimidated me—I assumed they were smarter than me and so much cooler in many ways. Most of the time I was lonely and sexually frustrated. I knew you were supposed to have a girlfriend or boyfriend, and I did get crushes on girls. But I was afraid to say a word to them. It wasn't before my junior year that I was

really dating and began to have a sex life. Until then I did feel intensely alone a huge amount of the time.

It seems to me you always pulled yourself together. You never freaked out or went astray, not even in the voluptuous sixties...

Not even then. I always have behaved. I've only gotten stoned a few times in my life but never really went astray. I'm embarrassed but I never have. I even did my homework regularly. In those days the person who wanted to succeed at something in this world would leave that aside and instead participate in a sit-in. My feeling about sit-ins was: "It's important to come out on the right side but it's not going to accomplish anything—we're not going to stop a war because we're blocking the entrance to a Stanford-building." As it turned out I wasn't entirely right about that. And I'd still take my homework with me—being the only person studying during a sit-in. Can you believe it?!

TRANSCENDING

What impact did friendship have on you in your student days?

I always had lots of people around me I was friendly with. I was good at admiring them but I failed in making friends. Part of it was my self-protection against emotions that I had learned as a kid. Besides I was never good at having fun. I was a combination of being overly determined to do well in my school work and being shy or easily intimidated. I never could just hang out, laugh, and be silly. I envied people who could through graduate school and as a young faculty member. In later years, during my assistant professorship at the University of Michigan, we were all trying to get tenure, sharing almost identical fears, not knowing whether we were actually going to have a career in the fields we were spending so much time preparing for. But the others were still able to enjoy themselves and I wasn't. I would hang out with them—though without feeling free to make a deep bond and let myself go into friendship.

Did you accept yourself as being good the way you were?

No. I always thought I was basically a fake. It's like what I told you about that history professor, to whom I pretended I'd read books I hadn't actually read. I realize now he wouldn't have expected me to read so much. But even though I was working very hard (probably more than anyone else) and doing consistently well, I always felt others were the real thing and I was good in getting by. And frankly some of my response was right realizing that I was on the course to do something that wasn't good for me: being a literary scholar. Because I wasn't a literary scholar, I didn't have the instincts. I just loved to read. So I was doing the wrong thing. I invested many years in it, learned a lot, and can't be sorry I did it—but eventually the things I really learned were about life, not literature.

If in those days there were no friends, was there something like a first love?

There was a woman during my time at Stanford. I don't think I was

in love but I liked her a lot. We had a sustained relationship for the second half of my junior year and all my senior year. She was one year behind me. Then there was the question of going the same place she was going to or leaving for Harvard for graduate school—and I chose to go to Harvard as a young academic.

I spent five years there supported with a fellowship from the Ford Foundation including a summer stipend for research. I was very lucky. Though I must admit my parents would have financed me too. They were extremely generous with us—by far more generous than they were with themselves.

At Harvard I did fall in love eventually—with a woman much younger than me. At the end of my fifth year I went off to teach at the University of Michigan while she was still an undergraduate. I spent a long time being desperately lonely because we weren't together. Then finally she went off with someone else. And I was quite miserable for a couple of years.

How do you look back on your time at Harvard.

The myth of Harvard was bigger than anything I actually experienced. I don't know how to say this but I never felt like I ever really went there—that I was actually good enough to be there and belong there even all these years later. I always thought that somewhere out of sight were the real scholars, people more special than me. Like my mother and her idealization of great pianists, I assumed the real thing was somewhere beyond your reach. Maybe that's why all my life I've been ready to believe the best in people—assume a specialness in them whether or not it's there. It also made me willing to forgive those who were awful to me because I still was ready to believe the part in them that was good.

Almost all of your time at Harvard was devoted to writing your PhD dissertation. What was it about?

"The Art of the Familiar"—an examination of the meaning of ordinary life. The same subject George and I had discussed while walking to synagogue. Drawing on the poetry of Alexander Pope, Samuel Johnson, and George Crabbe, I tried to trace a transition from knowing that life was valuable (because religion, faith, or God told you so)

With Radcliff College dean Kathleen Elliott at his Ph.D. graduation,
Harvard, 1976

to a kind of secular affirmation of the value of life itself. I argued
that even when as writers they were giving secular explanations
they were still carrying religious feelings with them but searching
for a way for life to still have a meaning and a kind of dignity.
I couldn't get my work published though. And graduated into a tough
job market. But I had studied with the professors whose recommenda-
tions I knew would matter. And I'd spread myself across a broad range
of subjects so that I could apply for jobs that were late-seventeenth
century, eighteenth century, or early-nineteenth century. Eventually
I was offered jobs at five universities—which was probably the number
of total job offers for the whole rest of my class of forty people com-
bined. Most of them got no offers at all. I was offered jobs at Mount
Holyoke, Williams, Princeton, Wesleyan, and the University of Michi-
gan, all top-twenty schools of the country. That should have given me
confidence. But I chalked it up to having been strategic in my choice
of courses and then having been a good interviewee. I was good
at working the world but I never felt like I was competing.

**Choosing Michigan must have been triggered
by a longing in you to find some stability.**

Absolutely right. I chose perhaps the least prestigious of all the jobs offered to me because it was the one most likely to turn into a permanent position. My friends said: "You're going to turn down Princeton to go to Michigan?!" And I made up excuses besides security for it – but in fact security was the main reason. Once there I was committed to becoming a very good teacher. And in fact I won awards for teaching. Teaching at least gave me a way of ministering to help others find their way. I also wanted to get people a sense of what I was able to do in this world—that I could make things happen. I set up an interdisciplinary program called The Eighteenth-Century Semester, involving eight different departments in a cooperative effort. That way I started to feel a kind of efficacy and realized I had administrative abilities. Maybe, I thought, an academic administrator is what I really am—maybe I end up with a deanship. Though I had no idea how I was going to get there—there was a big hole to leap over because first you get tenure, then become a department chair. I had to get published more or I wasn't going to earn tenure. But when I tried to do scholarship, I dropped away from wanting to be a professor. Partially because my second-guessing about everything made it very difficult for me. But also because the scholarly world had no use for my idea of a shared-suffering community.

To buy time I applied for a one-year fellowship at the Rockefeller Foundation. It turned out that a senior professor in my department who thought well of me was friends with the person who was going to decide about the fellowships. He was ready to recommend me even though I wasn't doing very well with the academic part of my position. When I entered the foundation, the man who hired me—a distinguished professor from Duke—was about to return to his university. But there was no one to actually do his work. That's when I saw light at the end of the tunnel. Because maybe *I* could do it. I just seized the opportunity, went over to volunteer my services to the head of the arts division as well and was lucky. It was like a miracle.

You moved to New York to become assistant director, then associate director for the Arts and Humanities division at the Rockefeller Foundation. Living and working in Manhattan changed everything.

Up to then I had felt like my whole life was a rehearsal for when it would actually begin. But you can't think of New York as a rehearsal – it's real. Living in an apartment on Carmine Street in Greenwich Village I'd take the subway in the morning heading midtown, wearing a pin-striped suit. I'd walk up to 42nd and 6th Avenue where the foundation was and work like a dog.

In a group of young people who all had the same fellowship I was the one reaching out beyond myself. I took on every opportunity. If someone needed a volunteer I volunteered. And I knew I was doing good work. For the first time I felt I was in the right place. It was the most exciting time in my life. Believing in what I was doing as something valuable was a wonderful experience.

What did you actually do?

My core job was two things. One: cutting the first fourteen-hundred of the annual fellowship applications down to six-hundred, then helping to pick scholars (as outside judges about the subject matters) to review them. Two: helping to start new programs—like a video fellowship program designed to present other cultures.

My director, Alberta Arthurs, was a great mentor and inspiration. Both of us combined a belief in academia with a temperament that wanted to act in the world. Alberta, once she had decided about an initial direction, was happy to share the responsibility for making things happen. That's what I was good at. An early opportunity she gave me was an invitation to a conference in Maastricht. I didn't know anything about its subject—"The Cultural Dimension of Third World Economic Development." But I was able to prepare myself sufficiently to participate.

Alberta often came up with new ideas. In Philadelphia for example she had encountered a program for helping high school teachers to improve their expertise in the sciences. We expanded it to a national network of schools, bringing together universities, foundations, and cultural organizations in each city around the effort to strengthen the opportunities for teachers. We always went to schools that had

Attending a conference at the Rockefeller Foundation,
New York, 1981

real diversity—with all the problems that go with American urban-school systems. It was a lot of work and we made many mistakes, things that didn't last in the long run (because of changes that take place in school administration). But we knew that if we helped teachers the money couldn't be waisted as they were teaching poor kids. That's why I loved the salesmanship. Besides I met wonderful people along the way. The Los Angeles branch of the program—called *Humanitas*—is still operating after all these years. It became one of my entries into Los Angeles.

Over time we focused more and more on issues of minority inclusion and diversity. Eventually the foundation asked me to research and start a program in support of African Studies. Along the way I saw that museums had an unrealized potential to present African arts and culture and other less-familiar cultures in a new, complex, and constructive way. In time this lead to The Museum's Program, as we called it—in support of curators attempting new ways to present diverse art and cultures.

**"To control a museum means to control the representation
of a community and some of its highest, most authoritative truths.
What we see and do not see in our most prestigious art museums
involves the question of who constitutes the community and who
shall exercise to define its identity," writes art historian Carol Duncan.
Bearing this in mind I wonder: how did you make choices or set priorities
to give out grants while being authorized to do so?**

Somehow the choices were easy, even for me who usually hadn't
trusted my own instincts. Because we knew that empowering minority
curators—mostly African-American and Latinos who normally didn't
have the chance to do what they wanted to do—was a good opportu-
nity for bringing in voices that weren't heard. Suddenly they had
money and could exert influence in their museums. Besides we could
feel what a good idea was—an idea that would expand into practice.
And whatever I decided or did I'd first read about and research.
The problem with foundation work is that as long as you listen to
the grantees you can hardly make a big mistake. Because you have
a choice of so many good things and people coming to you. Most of
those who'd gotten far enough to be contenders were very good.
Sometimes it took them longer than estimated to get their projects
done but basically they were all delivering. In the beginning I tended
to read proposals like I was grading papers. Until Alberta said: "It's
not about a good proposal. It's about will it actually happen?!"

How would you know it would?

By judging the applicant's character. Alberta and I were pretty much
on the same track. Only once in a while did we have real debates and
one of us thought the other was doing the wrong thing. But she was
the boss so at the end of the day I followed her lead, which almost
always proved to be right. I remember her decision to support the
show *Hispanic Art in the United States*. I thought the title alone was
a false category because there was all sorts of artists from Puerto Rico,
Argentine, or Mexico and that there wasn't such a thing as "Hispanic
Art in the United States." Besides the woman who initiated it was
Anglo and not an expert in this field, she just had the idea. But Alberta
overruled me. She said the museum directors believed in this curator
and if the artists had a chance to be seen in major American museums

it would expand their commercial potential and their ability to sustain their careers; it didn't matter if it was a false category. And she proved right.

What were your own intentions, doing the kind of work you did?

The diversity issue went right back to my childhood desire that there be justice in the world. We all believed in justice. We all were trying to help produce a more decent world. The foundation's atmosphere was positive and hopeful and affirmed your instincts in the direction of equality. And then I clearly admired the people we supported. The light that was leading me was my will to justice and my admiration and faith in those who were working towards justice and equality.

Were you aware of the rather privileged circumstances you were working in?

Yes. And I threw myself into the work and loved it. It was opening doors in the city. Like a window through which you could see the whole world and create opportunities. One day a woman named Mira Nair came in for a grant to make her first feature film. She was married to a lovely man who had done some still photographs that demonstrated what the film was going to look like—and they were fascinating. Then, seeing her work—it was so beautiful, it just had to be successful. Eventually the foundation gave her a grant and Mira Nair made *Salaam Bombay*, this amazing movie which launched an exceptional career.
Another case was a young man, who came in and wanted to start a company bringing Shakespeare to school children, being totally passionate about it. Although his project didn't precisely fit into any of the foundation's categories, I could make it fit because we worked with education and opportunities. As it turned out it was the first grant this young man had ever received. Julie Taymor, highly respected in theater and film, directed his first production. Now he has built his own theater in Brooklyn. He's spent his whole life doing what he started out to do with great success. Like everybody we supported he was passionate, driven, focused, and trying to do good.
And yet, over time I started to become impatient with foundation work out of the sense that it wasn't difficult enough. There were so many

good people doing so many good things. I guess I needed something that would put me to the test. A real challenge.

TAKING OFF

**Generally speaking the 1980s were an era of great plight
for the City of New York: recession, unemployment, social tensions,
homeless people everywhere. You lived in Manhattan from 1981 to 1988.
How do you remember those years—the social and cultural life,
the arts scene, the pulse of the city and its change throughout the decade?**

It was a period of quite significant creativity. Recession meant that
rents were cheaper and there was space for artists to live. I don't have
earlier periods to compare it with but for me it was totally exciting,
like being at the center of the universe.

Did that include going to parties, the arts and museums scene?

I was never much one for parties. Once I met Janet we did lots of
things together but if we went to parties it was because it was her
friends. My New York was characterized by the richness of the cultural
sphere that seemed infinite. After a long period of thinking my life
had been elsewhere here it was: I could go to Columbia or NYU to
take part in a seminar or panels. I could learn about African American
Studies, Gay Studies, Women Studies, and support these emerging
fields. I could buy three separate series at the New York City Ballet
and see all the great Balanchine dances I'd only read about for years
while teaching at the University. I'd go to places like Dance Theater
Workshop, The Kitchen, or The Brooklyn Academy of Music to enjoy
its explosive creativity. I'd see works from The Talking Band or The
Wooster Group, from European artists like Giorgio Strehler, Pina
Bausch, and other individuals. I'd also meet some of the important
artists of our time, discover them as human beings coming down from
the mythic level to people who had real lives in the city. It was over-
whelmingly wonderful. And Rockefeller made it possible that there
was almost no separation between job and relaxation.

How did you adjust yourself, floating between the upper crust, the gravely poor, between high culture, experimental arts, foundation work, and the little time that was left for privacy?

I didn't have a big social life. My time was very limited. There was lots of communication with people at work though. At night as well as over the weekends I was seeing things. There was so much to be in the midst of that I didn't have any space to hang around with others even if I'd wanted to. However, I had an acquaintance from the university who'd moved to Manhattan about the same time and became a good friend. We would meet after work at a place called The Cornelia Street Café and sit and talk about economics and poetry. All of a sudden I was leading the life I'd been looking for when I went to Stanford: drinking coffee in a coffee house, talking about serious things. I also discovered wonderful bookstores everywhere because through the foundation I was getting into many fields at once and had to do lots of reading. It felt like a kind of paradise actually. Besides—at least according to my initial impression—so many people on the Upper West side looked like me. Finally I was in a place where there were lots of Jews. I physically belonged. And I loved it just as I loved the fact that New York was socially quite mixed. It seemed fabulous that there we all were. At last I felt at home.

And yet I sense you prevented others from getting near you as a private person.

My life was very work-centered. Though it never felt like work because it was what I was interested in. When I left the foundation, somewhere along the way I realized it was typical that people you thought were your friends turned out to be interested in you only because you represented money. So I kept awaiting disappointments. But: almost no one dropped away. Those I had become friendly with through foundation work turned out to stay friends actually.

Would you say that New York then was a different place socially and atmospherically?

Entirely different. Almost all of what I loved about it has disappeared: the bookstores, the diversity street by street, the sense of a cutting-edge

cultural life, of discovery and possibility. It was rougher then and being made up as it went along. Now all seems more corporate and wealth is what seems to matter. New York today smells of money; there's lots of great things you can buy but it's so much about cash it's like poison to walk through the streets. And the diversity of Manhattan is radically reduced, minorities are being pushed to the margins economically, geographically, and in every other way. There's still little remnants of the past, there is lots to see, and there are wonderful institutions. But it doesn't feel like it's cooking any longer. LA is where new dishes are being invented. New York is only the dining room where those dishes are being served. New York today is a fundamentally different place indeed.

**How did the occurrence of AIDS change the city
from your point of perception?**

I didn't experience it change through AIDS, perhaps because I didn't know what it was before AIDS.

You arrived in 1981, the year AIDS was detected. In 1984 it became publicly known. While the Reagan government withheld funding for medical research and treatment, thousands of patients, among them many artists, died. There were huge public demonstrations, not just in Manhattan. AIDS resounded throughout the nation – and you didn't notice it?

I saw the protests. But I didn't see the misery, certainly not in the beginning. AIDS was something I saw in the streets rather than among my acquaintances. Though ActUp and people demonstrating through the arts and in the theater were very visible, it wasn't on my radar. There were so many people who were new to me, that I wasn't aware of what was happening beyond where I was or worked. AIDS was not a strong part of my reality but education was, ethnic diversity, home-lessness, social class and poverty. I was probably more exposed to the fact of AIDS in Africa than I was in the US because of some medical people at the foundation working in the developing world. In the art world I certainly met gay people all the time, but for me they were absorbed in the category of artists.

You didn't (and don't) have to be gay to be hit by HIV.

> I understand that. But I think AIDS as a real fact came much more to
> my awareness once I was in Los Angeles. Because suddenly there were
> many more gay people around me than I had ever known. Or maybe
> I did know them in New York but just didn't have the category
> to identify them. I never singled them out as separate. When I got
> to CalArts we had students dying or being gravely ill of AIDS. That's
> where I most got in touch with people affected by it. And mainly
> through dance, as there were so many bright gay choreographers.
> I remember a dance concert where the dean told me, "This is one
> of the best dance concerts we've ever had at CalArts because for some
> of the students it's the only dance they'll ever live to make." There was
> a seriousness about what they were creating that was unmistakable.
> I remember one student, who was HIV positive, ending his perfor-
> mance nude in front of you on stage—it was overwhelming, the power
> of the work that he was doing. But generally at CalArts I rarely
> thought about whether faculty or students were gay—here too artist
> was the category. For me it was a "We're all in this together." Though
> only sort of as I realize now: Because I was in it voluntarily—they
> were in it compulsorily.

**You were nearing forty then—a bright, attractive, professionally
successful bachelor. Was it by choice you that were still footloose?**

> In New York yes. I did date but I had been single for so long I had
> more or less accepted I was going to remain a bachelor. I was dating
> women, meeting people, going out—and yet I was lonely no matter
> what I did. In a funny way I was alone any time I wasn't working.
> I remember there was a place called Father Demo Square at the end
> of my block, just a little triangular park where Bleeker, Carmine,
> and 6th Avenue meet. I used to sit there after work and at weekends,
> taking pleasure in watching the world go by—all the girls and all the
> people I'd never meet. I'd cross 6th Avenue to the basketball courts
> where wonderful African American players, just brilliant athletes,
> were playing their street baseball and I guess I just took it as an
> existential fact: I was alone.

How about dating in New York?

I was sexually attracted to people but never truly interested in those I was dating. It filled my mind for the time I was going out and afterwards I was lonely again. I really thought that that was the permanent condition of life: being cosmically lonely until you died and while you're alive you tried to do some good. That was me and my whole life until I met Janet.

The way you're portraying yourself reminds me of Saul Bellow and an essay on one of his novels which you wrote during your time at the University of Michigan.

I loved Bellow then and I still do, particularly for his own spiritual quest. While teaching a course on American Jewish literature at Michigan I was trying to figure out if writers like Bellow could help me understand the task of life and if, maybe, I'd connect to my Judaism through their version of Judaism it would offer me some guidance. I was always looking for what life could possibly mean. Much of the time I felt quite suicidal during those years. I wasn't brave enough to commit suicide but I certainly thought about it. I thought, "If I'm unhappier than this I can always end it." I also remember when Charles Whitman climbed up the clock tower at the University of Texas and just shot at strangers on campus, killing fourteen people and wounding many more. Somehow I understood that you could be so frustrated with life that you just want to shoot at it.

Were you loving life or loathing it, Steven?

There was mostly loathing, but then in New York, a gradual opening-up. My first year at Rockefeller (filled with scut work like answering correspondence for the director) was still in the not-loving-life period. Then, with Janet, everything moved in a new direction.

The first time Janet stepped into your life was at the Rockefeller Foundation. A committed author and producer, she was planning to set up a conference on film and history. How do you remember her, looking back more than thirty-five years?

Janet was brilliant, full of ideas, responsive to the world and: beautiful.
She seemed to glow. When we walked down the street it was as if there
was a spotlight on her. She used to have this pink, puffy coat she
called Moby Rose. I'd see the flash of it in the subway as I'd wait
to meet her at the station to go out to Brooklyn Academy of Music
or someplace else.

At Rockefeller, when she came in with two other women to raise
money for that conference on film and history, it seemed as if it was
only her and I having the conversation—we just started talking and
talked without an end. At some point, I think, the two companions
had to leave. Eventually, when I walked Janet to the elevator, I asked
if some time she'd like to go see a movie with me. I was a visiting fel-
low at Rockefeller at that point and didn't yet have a permanent job—
so doing that was totally inappropriate. But she was just magnetic.
Janet, being four years older than I, had been married for quite a while
and didn't want to get involved if it wasn't really serious. I told her
right away that I didn't think I could ever have a real relationship;
that I'd had one that had left me damaged and I didn't think I'd ever
have one again. But that was on one of our first dates. Over time
things started to change.

Three years later, when Janet was diagnosed with cancer, I moved in
with her to support her and make a commitment. I'm not sure if
otherwise I'd gotten up the courage to do it. Though I guess I wasn't
much help in any other way than supporting her morally. Janet
continued going to work during that period. On Friday, coming home
from chemotherapy, she was sick as a dog. Saturday she would feel
a little better. Sunday a group of friends she called The Chemo Brigade
would come over to give her company. Janet wanted to grant me some
time off, probably thinking that if I'd always be around I'd just wear
out. And of course there were moments when she was difficult: overly
sensitive, not taking criticism well yet being very critical of me. But it
never ceased to be a wonder with her. Janet's the most brilliant person
I've ever met. She's got a steel-trap memory and great intuition,
backing it up with analytical thought. Janet has this little bump on top
of her head and I always tease her that her brain is so big that it's
expanding and just pushing out of her scull! I never met anyone with
so many gifts.

Strong, intellectual, artistic women have had a major impact on you ever since: your mother. Alberta Arthurs. Beverly O'Neal, who was CalArts's provost, when you came to Valencia. And Janet Sternburg, the writer and fine artist who was to become your wife. Have women been your guides or guardians, giving your life direction?

That wasn't the case in college, graduate school, or at the University of Michigan. But at Rockefeller Alberta Arthurs absolutely became my mentor (even though she sometimes treated me and other staff like her children. Which I never really minded). I formed a good relationship with the vice president, Nan Robinson, as well. Someone I really looked up to was Richard Lyman, the foundation's President. He wasn't accessible in the same way but I learned a lot from him. Lyman, who'd been president at Stanford before coming to Rockefeller, was an honest, clear-headed man, willing to put up with difficulties. When he arrived at the foundation, it had a huge apparatus around the world but wasn't giving away enough money to justify the overhead. Too much went into staff—and Lyman changed that. Though everybody disliked it and he was not a popular president, I valued the fact that he was undertaking something hard and un-rewarding without arrogance and with a kind of humility. And he stuck with what he did—which is what I admire most in people, regardless whether they're nice or not or if I'd wish to be friends with them. It's about their being able to align their character with their career.

Is it there anything you particularly admire in a woman?

Basically it's the same things I admire in a man: intelligence and engagement with the world. Though women to me often seem to be better in maintaining friendships. Besides it's always been easier for me to talk about personal things with women than with men. Women have always felt relatively safe around me. Probably because I spent a lot of time making my mother feel better—a lesson I've carried with me in all my relations. Besides I never learned something like "boys together doing mischief" or "boys together doing sports" or "boys breaking windows while playing." That's why I never knew how men in most cases maintain relationships. With women that was not the issue. Although I have to add that some of them I have also

misled. Let me put it this way to be understood: the same part in me that wasn't making bonds with men wasn't making bonds with women I was going out with. The only difference was: with women there was a sexual element. It implied a greater intimacy—which my self-protectedness kept me from actually feeling. And so there was a kind of built-in deception, whether I meant to be deceiving or not—it just was what it was.

When I think about the two women I really formed deep bonds with—Janet in the first place—it was really because their minds were so interesting to me. They seemed to me braver than I was. Less afraid of the exotic. They also had ways of being in the world that combined mind and feeling. And, to be fair, there was or is also always an element of challenge in keeping their affection. I mean the truth is Janet can be hard work; she's volatile and easily hurt. Some of it has to do with my mother or sort of difficult women. But then again that's what I learned to love at an early age.

It seems to me instead that Janet has made your life less difficult—given how you were caught up in your anxieties in your high school years, isolated yourself at Stanford or as a postgraduate, and were suicidal at the University of Michigan. Meeting Janet must have been like a rescue or a revelation.

It was. She changed my life profoundly. The loneliness just disappeared. There is a connection to Janet I feel even when we are miles apart whether or not I'm with her. It's the strongest connection I've ever felt to anyone. Even when we're fighting I know she's there for me. There's a kind of trust that is unique. Janet thinks I undervalue her contribution at CalArts. But what she really doesn't understand is that she was part of virtually every difficult decision I made in those thirty years. She was just solid, always there. And all the things I couldn't do all my life in relationship to other people are wrapped up into her. I can't imagine being without Janet. The whole rest of my life, with the range of all of my emotions, is hers.

At at the CalArts Board Meeting, Los Angeles, 2017

RISING TO THE TOP

At some point Alberta Arthurs advised you to look for a new position. Pointing out there wasn't anything left for you to learn at the foundation, she told you she wanted you to "understand what the life of an organization is" by having "to meet someone's budget." Soon after, while looking through the Chronicle of Higher Education, an interesting position caught your eyes: CalArts was searching for a new president. But this implied you had to leave New York.

I loved New York and it would have been nice to stay there longer but I knew that at some point I was going to leave the foundation. It wasn't a sacrifice to do this—unlike Janet who had a world of friends. Janet gave up a huge amount in New York. She was known there. And it is very important for Janet to be known. Not to be famous but to be known. She'd done Manhattan Theater Club things, she'd published *The Writer on Her Work*, had been in women's writing circles, on panels, worked in public television—she had many communities there. And yet it was Janet who said that after twenty years of living in Manhattan she felt like she'd become a New York provincial, thinking nothing good could thrive anywhere except in this city and she didn't want to die with that being her total world view. Her friends couldn't believe she was willing to leave—leave New York! But I think we had the experience that a lot of people have with CalArts: you walk in the front door and you're hooked.

What is essential to be remembered about the time you were awaiting the board's decision regarding your application?

It was in spring of 1988, Janet and I were staying in Santa Barbara just to get away. We went to the beach to play ping-pong and I said, "Listen, I think we need to talk about this." And Janet said: "You know we don't. If it's offered we're going." And it *was* offered and that was that. Except for a little detail. Janet wasn't going to go unless we were going to get married. So I tried to think it through. Sometimes I try to make rational decisions about things that aren't rational at all.

Totally irrelevant. Finally I just popped the question—I didn't even know I was going to ask her at that moment. We were walking along Central Park South and I thought: "I want to marry you." And said it. In some way the best things of my life have been the irrational ones. The CalArts job was that way too—although Janet remembers I'd worried the question for months. And, in a sense, I had known for years I was going to marry Janet if she would have me. But Janet, contrary to me, is able to make decisions very decisively—so that when we went to CalArts I was going to go with *her*. Had she said don't take the job I wouldn't have taken it even if I'd felt it was right for me.

Let's talk a bit about the change your lives underwent by moving to LA.

Two weeks before we left New York Janet and I had a one-day honeymoon in Essex, Massachusetts, then went back, packed our things, and moved to California. At first we felt like Jack and Jill walking up the hill—we didn't know anyone, didn't know our way around, and needed assistance to get our lives going.

Shortly before we got here Janet was diagnosed with a reoccurrence of her breast cancer. Thus, one of the early decisions was should she stay in the east to get the same doctors to treat her or should she come out to Los Angeles. And Janet, again with amazing courage, came out with me to Los Angeles, did her research, found new doctors, taught herself to drive again by driving to her radiation treatments and was amazingly uncomplaining about it. I should have driven her but I was consumed with this job about which I had everything to learn. I was all over the place, circling around without actually taking part in any life of the city. In the morning I'd commute out to Santa Clarita without having anything to do with Santa Clarita except for CalArts. In the evening I'd go back to Encino without having anything to do with Encino except for the President's residence where we lived. It was a very strange axis. I was just determined to get where I was going— on the freeway, to a place and back again. My secretary used to draw me maps on white pieces of paper, and they were fine, except you were totally lost if you made one driving mistake. Janet didn't use the freeways at all but chose to drive on the streets and actually got to know much more of the city than I did.

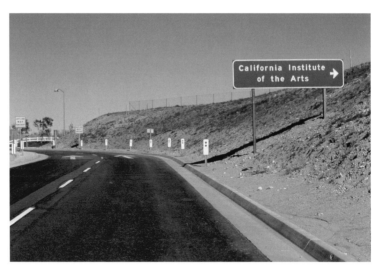

Offramp CalArts, Los Angeles, 1970s

Los Angeles was the place to be. It had an aerospace industry, enter-
tainment, agriculture and tourism—the United States' dream economy.
1988 was the beginning of a recession but I was so caught up with
CalArts's financial situation that I don't think I was aware that every-
body else was having hard times too. Every single meeting was a
challenge for me—driving to Burbank, to the Hollywood studios, or to
downtown Los Angeles. It was exciting to talk to the head of a motion
picture studio, to a banker or people from the city government. I sort
of knew how to charm them and I discovered that I was a good
salesman—there were days I thought I could be selling toothbrushes
instead. But it was also strange because all of a sudden I was *interest-
ing*. No one knew anything I had done before in my life but now I was
president of CalArts, a star without having done anything to earn it.
Suddenly I had a world. Whereas Janet felt she had to go out with me
because she didn't know anyone and if she didn't go out she wouldn't
meet people at all. And even though being recognized for her intelli-
gence and magnetism, people rarely understood who Janet really was.
She was and is so many different things. And she didn't know how to
tell people about it. Women of the leisure class would ask her, "What
art do you follow?," assuming she was interested only in one form

of art. And basically she had to try to explain that not only does she not just follow but makes art herself and that she's interested in many different things. Anybody who'd ever talked to her knew immediately that she's a special person. But here they treated her like the Beverly Hills wife. She felt invisible.

Had she seen it coming?

Some of it. But it hit her much harder to be treated as "the wife." Most people thought she was sacrificing her time by going out to fundraise with me. The fact that I was thanking others who'd done almost nothing instead of thanking *her* made it even worse. It probably took me twenty years to get that straightened out. Because unlike what others may have thought Janet was my ally all the time—and she was brilliant at making the case for CalArts: she helped me solve problems in talking with me intellectually and strategically. For one of our early parties she went to buy flowers at four in the morning at the flower market in downtown Los Angeles, because CalArts didn't have enough money to hire a florist to do it. She'd worry about every detail of those parties even when finally we had staff who could do it. Because if we had people over this was also going to represent *her*. And because Janet is a perfectionist. One of the things that helps us as a couple is that I'm not a perfectionist. I just want to get on to the next step. So now and then I tell her: "We don't have to do exactly the right thing—it's right enough the way it *is*!"

Recollecting your early days at CalArts you've conceded that it actually was a pretty rough-and-tumble place: "Like shellshock. No one had ever treated me that way since I was bullied as a kid...!"

The reason was the dean of the art school who apparently had been my advocate during the searching process but for some reason decided I was now the enemy and needed to be driven out from CalArts. I never really understood why except perhaps that she was committed to women's and gay issues, and suddenly I was talking about ethnic diversity without also stressing sexual diversity where CalArts had a proud history. CalArts was heavily gay and heavily female, almost perfectly fifty-fifty male and female. That was what we were. However, we were very white and that needed to be changed. The fact that I

didn't emphasize sexual diversity along my agenda probably could have made her think that this was going to be a general change of focus. It's the only way I can figure out that would have lead her to do what she did. Her faculty was afraid to talk with me or be seen with me. Students were set against me with petitions always accusing me of something new. I knew that if I'd respond to one of them or got one word wrong it would be used as a base for the next blow against me. I had to spend hours and hours fending off the assault against me. At night I couldn't sleep. Janet and I would be talking what to do about this situation—at four in the morning. Basically Janet said: "She can't drive you out of CalArts, you don't have to worry about that. You're the new president, you're the one dealing with the trustees. She can't win." And Janet was right. But I felt deeply vulnerable. People at CalArts claim the right to be very outspoken – contrary to foundation work where they rarely tell you you're all wrong because you have the money; it softens you up. Subsequently I had to learn to fight it out.

The agenda for diversity you aspired to referred to your work at the Rockefeller Foundation: becoming more intercultural, more inter-disciplinary, more international. It is thanks to your commitment that diversity has become one of CalArts's most significant features. I assume that Janet, in her very own way, has also had a share in shaping the institution.

She has. And most importantly so because Janet understood artists much better than I did. She understood the artist's desire for time. For a kind of protected space. Of not wanting someone to interfere with the way things are being done. If there were faculty in the schools I resented as self-reinforcing and less than first-rate, Janet would say: "They're doing a kind of work you're not interested in. That doesn't mean they're second-rate. Of course they're defending their art. And of course they're fighting you for making any changes. There simply is no other job that would let them do this kind of experimental work with a sometimes limited audience. If they cannot go on here, they have nowhere else to go!"

Janet had this kind of good sense starting from understanding what it was for artists to have a place where they could work and be. She has really helped protect CalArts and its people by trusting her judgement about them as human beings, whereas I often believed too much in their credentials and experience. Janet has also helped protect some existing programs, in many cases programs she didn't even like the way they were; but she respected their artistic intention. Besides Janet's helped us raise a lot of money. And she was a good problem-solver quite objectively. She could see the end-step way before me. Janet has kept me grounded and sane so I wouldn't be too upset about things that happened or lose track of what there needed to be done. By doing that Janet made me much more effective and able to survive as a president.

Could you have done the job without her?

Not a chance. We were in it side by side. Janet's part of my mind. Besides she'd never let me avoid a problem. If she could see there was a solution she'd want me to get to it. Although she often thought that once you had the idea you just did it whereas my approach is that anyone can have a good idea but the hard thing is to actually get it to happen. You don't just do something because you have the idea, you have to work through the steps of winning people over, raising the money, making compromises, doing the revisions—all the stuff to make it click in a real world of people with various ambitions competing. Let me give you an example:
When REDCAT (The Roy and Edna Disney/CalArts Theater) became a concrete possibility, Janet hadn't previously had much to do with the idea. I had been talking about it with the trustees for a decade as needing a CalArts downtown space. I'd made all the signals and kept looking but hadn't found the possibility. When it suddenly turned up I was thinking of something very modest. And Janet said: "What a great opportunity! You should seize it. Go visit theaters, figure out what we can do. Make it something significant." Janet made me see it. She made me realize I shouldn't settle but go for the best. This also exemplifies why I might underestimate the moment of revelation. Because my skills were, in most cases, not having the revelation but seeing the steps ahead, whereas Janet already saw to the conclusion.

When REDCAT opened, it was probably the best multi-flexible space in the United States. And that's partly owed to Janet's far-sighted thinking.

CRASHING DOWN

In early 1994, five-and-a-half years after you had arrived in Los Angeles, CalArt's situation was widely improved, not just economically. However on January 17, the Northridge Earthquake hit Valencia and basically reduced the campus to rubble. What had seemed like a phase of consolidation turned into a disaster.

Unfortunately, yes. When I came to CalArts in 1988 it had an annual structural deficit equivalent to 10 percent of the operating budget. An analysis by the vice-president for administration confirmed that we were three-to-four years from going bankrupt. By early 1994 we'd found ways to control expenses, raise money, and get back to a solid budget—without letting anyone go. We'd appointed a number of gifted new deans, people were behaving civilly to one another (which they had not been when I arrived), and we had recruited many wonderful new trustees. I might have thought my work was done. And then it happened. Janet and I were up in Mendocino about to celebrate her birthday. We heard in a local bookstore that there had been a huge earthquake in Los Angeles. As the LA airport was closed we couldn't fly back immediately. We had to go to Santa Barbara, where Judy, my secretary, picked us up and drove us to the hugely devastated campus. Gas mains had broken with flames shooting up out of the street, it was one big emergency.

Although there was no electrical power and the main building was damaged heavily, you went in and made it through darkness to what was left of your office. That way you could save your Rolodex containing hundreds of addresses and another item precious, though for different reasons.

The Rolodex was going to be essential in the weeks ahead. But then there was also a Sugimoto photograph, which I had shipped by Ileana Sonnabend Gallery from New York for Janet's birthday. I knew that it was in the front office but had no idea whether it had survived the quake. We don't buy a lot of art; this, for us, was expensive and

so I had to find out about it. When I came in, it was still in its packing crate. So both items could be saved...

... representing very different aspects of personal significance: your wife—and the institution...

... the only aspects that truly mattered to me.

How did you cope with facing the ruins of what you had worked so hard to improve?

At first I was paralyzed not knowing what to do. Everything needed to happen at once. But no one instantly knows what to do when an earthquake hits. I was lucky we had a vice-president for finance and administration, John Fuller, who had lived through previous quakes and knew how to address problems of emergency - for instance how to get a construction company in to turn off the gas and repair the lines. He became one of the heroes of our stories insisting on accompanying anyone entering the ruined main building: "If finally someone's going to get hurt I have to be able to say that I thought it was safe enough to go in myself." I was impressed he was taking it on him but he (having once been president of a bank that had been robbed) merely replied: "If you have been robbed at gunpoint an earthquake is not so frightening any more!"

There were hundreds and hundreds of decisions to be made. In the past I would have worried about them for days, now I had to make them right away. Most people go wrong because they don't have models of what to do right in front of them. They have to make it up entirely as opposed to having had a mentor somewhere along the way to point them in the right direction. I had had such mentors not just at the foundation. And, I heard my father say: "All you can do is the best you can do." If I failed, ok I failed, but I still had to go ahead because I was the president. And then it turned out I knew every step of the way what the right thing was to do as if everything in my life up to then had been in preparation for this moment.

What were the practical implications you had to consider?

What mattered most was to keep the school open and to stay out of the newspaper. It was admission season. If everyone had learned our facilities were severely damaged, students would not enroll. So we had to keep a low profile. I wasn't ready to ask people for money as we didn't know the extent of the damage; but I started to let them know that we were in trouble and asked them for advice right away. Within a couple of days I started calling institutions in San Francisco who had gone through the Loma Prieta Earthquake five years before. One man who I was put in touch with came down to Los Angeles immediately. I hadn't even paid for his plane ticket. He came and helped to save CalArts. And the key thing he told us was to have a lobbyist to help us in approaching the Federal Emergency Management Agency. "FEMA never have enough money for everyone," he said. "That's why you need to get a lobbyist to help you make your case in Washington." Which was exactly what I did.

Once we determined to go ahead with the current semester it was clear what we needed to do. In order to be able to hold classes until we'd find alternative space we rented sixteen party tents, one for each academic and administrative department. It was very inspiring to see how people, administration and faculty, rose to the occasion. The registrar, for instance, brought her mobile home to campus. It was powered by a generator so she could run her computers, do the registration and financial aid for the semester ahead. The food service was the most damaged part of the building. Though they weren't supposed to enter the ruins, the food people went in anyway to empty the refrigerators because they knew that otherwise all the food was going to spoil. "What are you going to do with it, how are you going to cook and serve?" I asked, and they replied: "We're going to cook on outdoor grills and then serve our meals." Just amazing. I never liked the idea of an army. But here—as people were taking responsibility— it felt like a wonderful thing.

Meanwhile I had already sent out staff to find rental space. Knowing others would need space, too and availability would be limited, I said to them: "Don't worry about how we will use the space, just rent it." Through this we found fifteen properties but together they did not add

After the Northridge Earthquake. Addressing the CalArts student body and faculty, Los Angeles, 1994

up to enough room. Our trustee Michael Eisner, who found spaces for the Walt Disney Company, gave me the number of a man who then identified a disused Lockheed factory only a few miles from campus. Another friend of the school called the State Attorney General who called the head of Lockheed for us, with the result that the we could rent the 156,000-square-feet-space for eight months for one dollar, which made all the difference.

CalArts is very decentralized, which can be a problem administratively. In the wake of the earthquake it turned out to be a huge advantage. Once we had space to put everybody in, faculty got their programs up going again with amazing speed because the schools were used to making their own decisions. Yet, many faculty thought that CalArts wasn't going to survive. They still thought it was too good to be true: the Bauhaus and Black Mountain College hadn't made it so why should CalArts, even more so under these circumstances? By the end of January 1995, at our annual board meeting, one faculty member said: "Look, these other schools went down, why don't we just spend the rest of our endowment, have a good last year or two, and call it

quits?!" And I replied: "If that's what you wanted to do you should have told me before you hired me. Because I don't have it in me to oversee letting a good thing die."

What did it take for you to generate that kind of strength?

Imagine a child trapped under a car and suddenly you're strong enough to lift it up and rescue the kid. That's what it felt like in the beginning, it just was unthinkable you couldn't do it. And it didn't feel particularly heroic, it just was what we needed to do and what I needed to do as the president. The hardest task in the steps towards a recovery was actually a very small thing: as we kept on uncovering more and more damage, the construction company, which had come to our aid initially, wasn't big enough for the task of rebuilding. It was clear to me we couldn't keep them. But our vice president, John Fuller, argued that the company had been there when we needed them and now we were going to let them go without sufficient cause. I didn't just want to overrule John, it took several weeks to bring him around to my understanding of our challenge. But then no big construction company wanted our work. We were in the suburbs, they were in Los Angeles, the freeways were broken and we were going to need hundreds of workers to get the rebuilding done.

My Board chair contacted a major developer of the previous generation. He was now retired, mostly doing good works for non-profit organizations in Los Angeles. This man contacted a construction company he had worked with and basically asked the retired head of the firm to ask his son to whom he had passed on his company to take our work: what we needed was an open-ended contract promising to provide as many workers as it would take to get the rebuilding done by September 1995, the opening of fall semester—without knowing how much damage there actually was going to be. One aftershock, probably a month later, did another four-million-dollars-worth of damage. No one would guarantee something like that. And yet this man accepted. It took effort, cleverness, and countless hours of work. At times I was so exhausted that I thought I'd faint. It felt like falling down a hillside without an end. Many months later, when it was all over and done, Janet commissioned a designer to make a beautiful graphic piece for me that I still keep. It quotes a rabbi

saying: "I am tired and all my energy is in my tiredness." As for myself that was very true.

You even had felt the pain of the building during reconstruction...

Probably because all of a sudden I saw this place that had served us every day for the past six years savagely wounded. That really took hold of me.

In Flesh and Stone, a book by Richard Sennett, the author draws an analogy between the human body and the physis of a city. Exemplified by places like Athens, Rome, Cologne, or Paris, Sennett describes the vulnerability of urban space, comparing it to the human organism since both are easily thrown out of balance when their longer-term structures are interfered with whether by natural or human forces. CalArts's open wounds and your reaction to it reminded me of this.

When I came in on the second or third day after the quake, I could see that there was dust from the concrete at the base of the columns of CalArts's huge central hall. Initially I thought it was from termites. Then I learned that the steel had been so twisted that it was ground concrete as the steel tried to return to its original alignment. This seemed quite striking to me—that it was trying to restore itself—like a living creature. I also remember how it terrified me when, by pulling back the skin of the building, we could see the damage done within: everything was torn and splintered, it really looked like wounds, these big, diagonal cracks in the heavy blocks of concrete. Some of the concrete block was so torn you could see through the walls. On the outside of the building openings had appeared. The sight was quite dramatic. And yet we were assured the building wasn't going to collapse, it was clearly unsafe but held up by its own structure and weight.
As the construction workers made their way through the multiple wings to the center of the main building they uncovered more and more damage. At first it was fourteen, then twenty, then twenty-eight, then thirty-two million dollars we needed for the rebuilding, it kept going up and up and up. We had been so broke as we'd fought our way back that we'd been basically worried about every five-hundred-dollar decision. And suddenly, without any real security back-up, we were

forced to spend millions! But we knew we just had to keep going if we were to have any chance of saving CalArts. Had there been a thorough analysis of what needed to be done before the reconstruction we would have lost four months and wouldn't have been able to get everything rebuilt in time to enroll a fall class, which would have meant other layoffs and many more millions of losses. The way we had it done was painful but at the same time an exciting experience because everything we did was new and there was lots of reaching out and learning for all of us to do.

Given that twenty-five years have passed since then and new students are coming to CalArts continuously, having no idea that once their campus has lain in ruins: is there any lesson you'd like to be passed on about this particular history?

I guess it is that we just *did* it. There was no text to tell us what to do. The biggest challenges come down to common solutions. Big problems are often just a bunch of small problems combined and you don't have to be afraid of them, you just go through it. I'd also like to have remembered that CalArts had a structure that often seemed chaotic to people but in fact worked beautifully even without clear lines of authority because people took responsibility. That's the true reason why we didn't end like the Bauhaus or the Black Mountain College. When there's a disaster you often hear: "We're going to emerge stronger than before." Well we actually *did* become stronger. Two or three faculty left town altogether, they didn't even tell us they were leaving, the fear of the earthquake being just too much for them. Even though I understand you can't have control over something that is terrifying it was hard to be sympathetic, even more so as I saw what a community is capable of when it pulls together. We never would have built REDCAT if it hadn't been for the confidence that arose from our successful recovery from the earthquake. We didn't have enough money when we started to build REDCAT but we knew it was import-ant for the future of CalArts. And so we did it. And emerged with a whole new level of self-confidence. A "we've-gotten-through-that-now-we're-getting-through-this." It's an inheritance that still lives at CalArts and, I hope, will prevail.

**It seems to me it took the Northridge Earthquake for you to prove
that you were not just a scholar trying to run an institution but a loyal man
ready to act, take risks and full responsibility in a huge crisis and,
by doing so, save CalArts's physical existence.**

I never really trusted myself until the earthquake had happened and
I never really felt worthy to be alive until after we recovered from it.
Along with Janet the Northridge Earthquake is the most important
thing that's ever happened to me. I guess if St. Peter at the pearly gate
should ask me: "Why should I let you in?," I'd say: "Because I was
at CalArts and didn't run away."
During my first years I'd assume that people would think what right
did I have to be a president without having worked my way through
the steps of academic management... I always felt like there was this
hole under me. And suddenly, when it was all over, there was no hole
any more. I felt like I had grown up, like I had passed my final exam.
I have a tendency to depression but I didn't let it stop me, I just carried
on. We all just kept going as we all gained weight eating donuts all day
long just to stay warm and keep up the energy.
There was this wonderful moment when I went into my office with
Judy McGuiness and a second secretary. My predecessor Bob Fitz-
patrick had left all sorts of liquor bottles in the shelves—I think he
entertained more than I did—and they'd fallen down and were all
broken. There was a terrible mess on the floor, everything was a mess.
And we just began to clean it up. And at one point I looked up and
said: "Look, what we're doing...!" And Judy said: "Yes, I guess we're
just good workers." And that seemed like a great thing to be—a good
worker.

What's your definition of a "good worker?"

Judy, being thirty years at my side, is a good worker indeed. Totally
self-respecting, always good-spirited, doing what had to be done, even
working late—an exceptional person. In those days we would have
student protests about one thing or another and I remember Judy
calling me to announce some protestors coming up from the theater
school: "You should know they brought some friends..." And I could
hear from her voice it was a lot of "friends"—in fact it was the entire

student population of the theater school all coming into my office until it was packed with people cheek to cheek. One of them said: "We just wanted you to know what over-crowding feels like." Then they all left except for three or four with whom we sat down and discussed the situation. Any other secretary would have said: "There's a terrible protest out here, maybe we should call security!" Not Judy, she was just totally unflappable whatever happened. I could just trust her. Trust is in some way the most important thing in a person you work with. Sometimes, especially in the last few years, I was cranky a lot; I think I was getting tired. And Judy just put up with me even when she heard me in there swearing to myself. Judy is not someone who'd swear or use that kind of language. But it didn't alarm her, she just knew we were on the same side. Valuing people for what they can do and not rejecting them for what they can't is one of the great lessons of CalArts for me. Because there is no perfect person for any job. We are all imperfect.

SHAPING THE FUTURE

**What's the most untypical thing
you've ever done Steven?**

The truth is: buying a house. Years ago, after having spent two months
in San Miguel de Allende in Mexico I had spotted one we both really
liked and so I said to Janet: "Let's buy it!" Without comparison
shopping, without thinking if we should do it or not or what sense
it would make. I'd always felt that wanting to do something was no
particular reason to do it. But then we just did it. Looking back, I'm
sorry I've been such a good boy. It feels like a waste, but that's how
it's been.

**Did you grant students at CalArts the freedom
you never quite allowed yourself to enjoy?**

Absolutely. I always told them: "Once you start to work you're going
to have to be a responsible person. The further you go, the more you
are trapped into living up to various demands. You'll have a family,
you'll have to feed them, whatever you do you'll have responsibilities.
Right now you don't. Take advantage of it. Do what you really want
to do." However, I have to say that this was in my first twenty years
at CalArts. I didn't say that as much in my last ten years when
I grasped the increasing precariousness of an artistic career combined
with student dept. Then I urged the students to go out into the world
and do things that gave evidence of who they are and of what they
are capable so people would notice them. I wanted them to be smart
about their future and encourage them to be entrepreneurs on their
own behalf.
It is only now that I realize I was no longer taking into account the
kind of spiritual quest involved in artmaking. Had I been doing then
the reading about politics and economy I'm doing now I would not
have adopted that language of entrepreneurship. I still would have
talked about substance—that you've got to figure out a strategy for
yourself and how to put your life together. But I would have always
balanced it with one's personal and spiritual quest. Because that has

126

little or nothing to do with how you survive economically. It has to do with how you survive as a human being. Once you merely call it entrepreneurship you cut yourself off from three-fourths worth of a life in the arts.

Reading your annual CalArts graduation speeches of almost thirty years it's remarkable to notice the way you embraced and encouraged students and alumni: with kindness, pride, admiration, and generosity. Thousands have graduated during the era of your presidency, some have risen to fame, others are having successful careers, receiving prestigious awards and accolades. You wanted for them the best, gave the best, and got the best.

Yes. I so much wanted them to have the satisfaction in artistic lives my mother didn't have. But I also wanted them to understand that a good part of this involves defeats.
Life is based on defeats if you are trying to accomplish good things. You are always defeated in part and then you go back, try again, and get a little closer. The more you try to do something genuinely original, genuinely important, the more setbacks you will have. You just have to pick yourself up and keep going. It sounds like a cliché of self-help but it is the truth. You need to keep going. I was always worried that I, like my mother, would give up. But I haven't. I wish I had known what I know now when I was the age of a CalArts student.

Your words remind me of Samuel Beckett:
"Ever failed. No matter. Try again. Fail again. Fail better."

Failure is what it's all about—I would say that's CalArts's credo in general. Because in part it's an artist's basic experience: the joy of making, then it not being quite what you had imagined, then going back and trying to make it better.

Struggling as an artist's philosophy of life?

Yes. Because life is a struggle anyhow. Every year at graduation when I looked at these students I had to fight back my tears. I was moved by their courage, their going out in the world, turning nothing into a beginning. More than anything I wanted to support that courage and try to be sure CalArts provided for them the tools to act on it.

Addressing the CalArts student body and faculty,
Los Angeles, 1990s

I guess that is also what you expected faculty to do.

> Very much so. Though I always thought it was kind of a paradox that
> we hired faculty as focused and driven artists and then asked them
> to put aside their own egos in order to help the students develop their
> own distinctive artistry. That's a really hard thing to do because
> obviously it's about their own art that needed to be pursued too.
> I always wanted the same things for faculty as I did for students.
> But I felt the students had to come first. And that was most important
> because they weren't going to repeat their college education elsewhere.
> Therefore, what I really wanted to see on part of faculty was commit-
> ment to the students and generosity, especially generosity. Faculty
> I admired were student-centered, listening to them and guiding them.
> It wasn't about passing on the essence of their gifts, it was about
> helping students find their own direction. And a reasonable percentage
> of the faculty at CalArts lived up to that idea despite the heavy
> demands it placed on them. On a wider scale what I really cared
> about was CalArts's potential to expand opportunity and reach out
> to people who before enrolling did not have every opportunity.

That's why you set up CalArts Community Arts Partnership (CAP), involving CalArts students to work with kids. About 300,000 children and youth from all over Los Angeles, most of them from vulnerable backgrounds, have been given access to this program since 1988. I suspect that it has substantially added to your life value and meaning.

Absolutely. From day one CAP was a huge satisfaction. No matter what I thought about anything else, I always believed in this. Because I knew it would be a good opportunity not only for the children but also for our CalArts students. By teaching and inspiring the younger artists CAP gave our students a legitimate reason to be exposed to more of the facts of life.

In the beginning the students were not always welcome being white in a mostly Black, Latino, and Asian environment, where examples of Black, Latino, and Asian students were needed as role models. But I trusted that in the long run it would justify spending the money and work, and it did. In fact one of the things I am proudest of to this day: after the Northridge Earthquake, when the freeways were broken and it was impossible to get around Los Angeles, all the CalArts students teaching in CAP found a way to get to their teaching assignments. They knew the kids were probably going to be there waiting, and even if it was just mostly true, that's what I wanted. CAP has changed the lives of everyone involved: it has helped the younger students, giving them opportunity. But it has also helped CalArts students to be ready to live and work in a diverse world. And it has helped CalArts itself to become more diverse and to demonstrate its worth to the LA community. Over the years CAP has even exerted influence outside of Los Angeles—it is being copied by other colleges around the country.

Have you ever been disappointed by anything in conjunction with CAP or CalArts?

Inevitably there were a few faculty who disappointed me as mentors in the CAP program or as mentors at CalArts. They were driven to do their own artistic work (which was also what we had hired them for), and after years of doing their personal work and the CalArts teaching they couldn't balance the two any longer but needed the financial base CalArts provided for them.

Amindst CAP youths and CalArts students,
Los Angeles, 2015

With CAP I always thought the important factor was not what the kids
learned about art, rather it was always that they learned they had
something worth to say through their art, that they were valuable
people. I didn't particularly want them to become artists because for
most of them being an artist probably wouldn't be a smart choice
(although in fact many of them turned out to become artists.) What I
really wanted for them was to get in touch with college students and
go to college too. I wanted them to gain confidence and opportunity.
For our regular CalArts students both the confidence in their own
value and the refinement of their vision and skills were important.

**It's interesting for me to realize that while talking about
a social cause your intellectualism happens to get
overruled by emotions.**

One of the things you are showing me in this process of conversations
is that there's always emotion underneath. Rationally there's argu-
ments pro and con but the emotion hides behind the intellectualism.
I realize that subconsciously every major decision in my life I've made
emotionally.

**Were there moments during your CalArts presidency
in which you think failed?**

Many things I wanted to happen didn't. Like a program for arts
criticism meant for the general public that I tried to establish before
understanding adequately that CalArts is about advanced thinking
and not really conducive to popularization. There were other areas
I tried again and again, made a little progress, but not as much
as I would have liked to. A good example would be the music school.
I felt it should pay more attention to popular music since many
students were destined to go in that direction. It took twenty years
of pushing before we made significant progress in that direction.
And then there was a sort of failure towards the end that might have
been a success had I stayed there longer: I wanted the faculty to
understand that we could save the students a huge amount of money
if, by the design of our program, we would make the time to gradua-
tion one semester shorter. For me that was reason enough to try
to do it. But faculty was so wedded to what they understood as the
four years it took to complete an education that we made no progress
on that. A certain number of students are allowed to graduate earlier
anyway because they're regarded as outstanding. So maybe that's the
compromise. In theory you can complete all your courses at CalArts
satisfactorily and still not graduate if faculty don't believe you're far
enough in your artmaking, although that rarely happens. But the goal
is a good one—that we're responsible and they're responsible to get to
a certain level in their artistry. That the time at CalArts is not just
about a bunch of courses or curricula but about developing as an
articulate artist.

**I noticed that there's no visualization of outstanding
CalArts alumni to be found on campus. Wouldn't it be
encouraging for students to see that there are former
graduates being widely acclaimed?**

It was important not to make a fetish of success. Of course I wanted
the students to have the opportunity that come with success in the
world. But I am just as happy with those who go on making art
through a life without the rewards that may come with professional
acclaim. A few years ago I went to a Christmas concert and a woman

from the chorus came up to me to tell me she'd been a CalArts music student. She was now doing something entirely different professionally but was singing in this choir. She kept up her music, doing it out of passion, and I thought that was great.

Other graduates go for years and years without apparent success until suddenly they're discovered. Like a music school graduate named John Luther Adams, who moved to Alaska and makes environmental music about vast open spaces. He is taken with the sounds you hear under your feet and all around you while being on the ice—just fabulous. We admired him for many years as did a small group of other people but he had little public recognition. And suddenly the world's caught up with him: he recently won a Pulitzer Prize and is now being performed more widely.

Which leads us back to what you've been preaching all the way along to your students: Perseverance. Believing in oneself. And sustainability.

Yes. I want people to go on. As much as I want myself to go on. I've always been afraid that I'd give up. As I sit here, I know that again it relates to my mother, to her not being able to go on. But the Northridge Earthquake has helped me to overcome that fear. There's no reason to be afraid if you just do it. I mean I've lived my whole life by a phrase of Antonio Gramsci's letters from prison: "I'm a pessimist because of intelligence, but an optimist because of will." It's really my credo. Because the intellect, pointing to the failure of our species, leads you to despair of everything and you can't give into that; and so the optimism of the will is there to refuse to accept what your intellect tells you and to do your part to prove your reason wrong. I never realized until just now I felt I've done enough as it were. Some stuff I could have done better. But I served CalArts well.

I'd think there's good reason to believe that all those former kids and students you have given hope, courage, and opportunity will do their share to carry forth a more cultured and learned American spirit. However, while having tirelessly focused on others, you have hardly ever focused on yourself. How self-aware and self-accepting are you in your seventies?

I'm much more self-accepting than I used to be. I also trust myself more than I did. And yet I still carry around the fear of falling into a deep hole of depression, feeling life may not mean anything. When that took hold of me in earlier years, I set myself the goal of learning something as a way to get focused. Later I imagined that once I retired I would read the classics and listen to classical music. But in fact what I do is spend my time working for the Thomas Mann House in Los Angeles, reading political economics, political science, history and democracy... I feel that I have done enough to justify having been alive. However, if I'm not working towards something, I won't be happy. I think I've spent my life operating on the principle that trying to help others while you're alive is at least a value, even if life doesn't mean anything. You still have helped people while you're alive, and helping is a value without God or someone having to declare it.

Are you actually content being around yourself Steven?

I wish I could be content just to be. That's what I was looking for years ago in American-Jewish literature, especially in Saul Bellow's novel *Herzog* and in some of Woody Allen's movies. After scrambling and scrambling and scrambling their characters stop and experience just being alive—and it's enough. That's where I'd like to arrive to. At the very end of *Herzog*, which is about a man who is in turmoil all the time (writing letters to people, always explaining things), he says: "I am pretty satisfied to be, to be just as it is willed, and for as long as I remain in occupancy." And what fascinated me about it is the "just as it is willed." Herzog/Bellow is actually accepting that some-thing is willing him to be here. That there's an exterior meaning. And if something is willing us to be here then there is a ground for being content just to be here. But I don't feel anything is willing us to be here. Thus being content around myself is not my usual state.

Have there been moments in which you felt literally happy, alive, and complete?

I remember such moments with Janet, totally unexceptional ones like doing a road trip, then stopping for a sandwich at some place, and all of a sudden it sneaked up on me that "I'm *alive*, that *this* is it!" Similarly at night when I'm awake and Janet's in bed asleep beside me

and I realize: "Wow, there she is, right next to me! We had a fight before we went to bed, so what? Because—there she is!" My whole life until Janet and CalArts felt like a rehearsal. I was preparing for something without knowing for what, and when it came I was ready to act on it. But the feeling about a precious moment is not something you earn exactly. It's something that just comes over you. Like during this series of conversations when we were talking about my mother and all of the sudden the reality of her came over me just overwhelmingly. I realized how attached I felt to her in a good way and felt so grateful for it. I also remember being overwhelmed while sitting at REDCAT realizing: "We did this! It didn't have to happen but there it is!" And then, of course, the presence of children at CAP made me happy. Or standing one night behind the counter of REDCAT's bar like my grandfather. Or being good workers cleaning up the mess in my office in the cold, eating donuts and gaining weight, being in it together despite an earthquake—those are other great moments I do like to remember.

Is it true you don't miss CalArts after almost thirty years or are you just trying to push away a hidden sadness about it?

I miss the sense of security I had being embedded in a community with people all around me with all the casual interactions that it entailed. I also find myself missing people who were selflessly working to try to deliver for everybody else. I miss their non-neurotic commitment. And I miss, miss, miss the students with all their hope, promise, energy, and possibility. I also do find myself pleased when I run into faculty, trustees or alumni on the streets, to have that moment of sharing our love of CalArts and of having worked together. But I don't miss the day-to-day responsibility of pushing and pulling things forward.

How do you handle loss in general?

I'm pretty good with loss. Or I have been up until now. Because I create an emotional distance between myself and most things, even things I love.

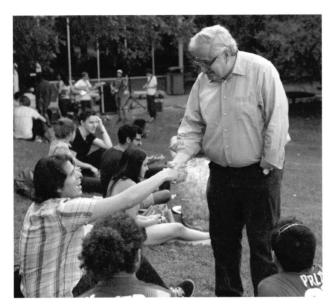

With CalArts students, Los Angeles, 2016

I guess you think you do.

Well true, I think I do. But as opposed to Janet, who wants to feel
the full weight of loss, the full weight of happiness, of any experience,
I grew up not wanting to feel what was going on around me. On the
other hand, my self-isolating helped me because I didn't feel the full
weight of someone's bad behaviors or failures, my own failures
included. I felt much more what was good, things I wasn't afraid
to let in, than what was less good or not good for me at all. I'd like to
let the rest in now. I'm afraid of it too. But not as much as I used to be.
I always thought that once I'd left CalArts one of the things I would
miss the most was this shiny armor I used to wear as the president.
With it I thought I could face the world without the fear of being hurt.
And now? I quite enjoy being in the world without my armor. I feel
as if something could happen that couldn't have happened before.
And in fact things *are* happening. People are entering me in a different
way since I took off the armor. Or since they took it back from me.
Getting past this barrier I put between myself and my experience,
myself and the world, will be the work of my retirement.

When I asked you how you'd handle loss I was also thinking about people who you have once been close to.

Since I've left CalArts, my losses—things I made no space for in my mind in all those years—are coming back to me: My mother. A girl I dated as a freshman at Stanford who committed suicide. Or a high school friend Janet had to show me he was gay (because I didn't notice)... More and more these people are in my mind. CalArts was filling so much space that there was no room for anything else except Janet and our beloved poodles, though in no sense did I feel deprived because CalArts in itself was so full and Janet is so full. But now, with a little more time, I feel those losses are coming back to me as presences, as if those people weren't dead.

How do you handle your own mortality?

I'm not afraid of it. I don't think I'd really mind being dead. I mean I wouldn't experience anything anyhow as I don't believe in afterlife, so if you're dead you're dead.

I've pretty much lived the life—a full life—I wanted to live. And it was fine. I could just say goodbye to it all except for Janet, I'd like some more time with her. I want to watch out for her and enjoy her creative successes. And otherwise? For years I used to write in my journal I wished I had stronger connections with Europe. And now between the American University in Rome, Villa Aurora, the Thomas Mann House, and friends in Berlin I feel I'm indeed connecting with the continent. Even if I still want the world to be a better place I feel like I've gotten pretty much everything I wanted.

You've been able to live up to the American Dream.

I am a great beneficiary of the American Dream. I've had opportunity almost beyond reckoning. My parents didn't—both my father and my mother grew up poor. But they were able to make their way. My father who grew up in the Depression used to say: "You could lose everything but no one can take away your education." Growing up middle-class, my American Dream was that you could be from my background and *still* become a sophisticated, worldly person. That you could go to a great university and learn. That the world's culture was yours too.

With Germany's Federal President, F. W. Steinmeier.
Inauguration of the Thomas Mann House, Los Angeles, 2019

That you should have it and education was the route for having it. My American Dream was about immigration, justice, diversity, and opportunity. One of the things I go on feeling guilty about however is that it seems to me I got through the door while it was still open, whereas for others the door's now closing or closed. I tried so hard to keep it open for as many as I could but my fear for America is that we're closing the door for everyone who's behind us. Which equals giving up the whole enterprise of American democracy.

There used to be this notion of American exceptionalism—that somehow we thought we were better and that there were things we would always stop at. And suddenly we have a President who doesn't stop at anything, a Republican devoted to the wealthy who help them get elected and a Democratic Party with very little idea of an alternative vision to offer. Suddenly all of what is bad about our history

comes up. It's a shock and a disappointment to find the evils of our past are closer to who we are now than we thought. I never really considered us as one of the real problem nations in the world. That's why I feel privileged to work on the Thomas Mann House project at this stage of my career, exploring how the virtues of democratic choice and social progress can be maintained. Germany and the United States need one another if either is going to keep up the path toward social democracy. I do realize Europe's having more and more trouble of its own but it still takes care of its populations, and without examples of the good it's almost impossible to believe something better is still possible. Education in large measure is about being exposed to examples. That's what I believe in.

AN ORDINARY LIFE

One question is left. The one you've never found a language for but all through your life—as a boy, a student, a scholar, a president— were thinking and worrying about: "What gives value to an ordinary, non-heroic, non-exceptional life?" Have you found a language for it now?

When I was younger, it was scarier to talk about it than it is today. Because I hadn't lived an ordinary, non-heroic life, I hadn't lived *any* life except not doing enough for my mother. It felt like I couldn't answer the question as I couldn't see a course of action. Like I'd just fall into a black hole of depression and never again get out. And if all I really liked to do was read and listen to classical music—well that couldn't be enough justification. Now it's different. My answer, which you really helped me find during these conversations, has to do with service in the cause of justice and equality. With helping other people. CAP in the first place but also CalArts was what I could believe in and stuck with. That's something to be proud of and worth doing even if it doesn't ultimately answer the question about what this life is for. But at least it means I've done something that seemed self-evidently of worth to do.

There's a video going around in the internet that shows a baby elephant getting caught in a swamp and all the other elephants gathering around pushing the baby out of it. It's moving to see them saving their young. And even if it's just a result of evolution and survival of the species, I guess I feel that's what we ought to do too: saving the young and those in need—Helping other people.

Has worrying about the "value" of life been so haunting because you felt or feel a longing to prove worthy to life itself?

What you want is some self-evident truth to base your life on. Reducing the pain of others is about as self-evident as you can get. Even though I know it doesn't get to the bottom of things. But it seems good enough. Probably it goes back to my adolescent existentialism,

to a sort of dignity of committing to a cause and living up to it even
if it's just pushing the rock up the hill, knowing it's going to roll back
down again. I'd rather have that feeling that *Herzog* has at the end
of the novel, of being content with just being, but I don't feel a deeper,
a genuinely spiritual, or transcendent purpose.

**Would you have been ashamed had you just lived
your life without a cause and let yourself go?**

I hope I would have been ashamed. But part of me says we do what-
ever we're coded to do by our genes and our previous experiences.
So probably if I'd lead a useless life, I would have been coded to think
it was okay the way I was living. But I'm not coded that way.

**Think of the man we saw the other day: sitting on a bench,
hanging in there, dozing in the sun for hours, half naked. He wasn't
pausing or relaxing. He was pretty much letting himself go and had
lots of time.**

I'm ashamed of myself for not having given him something. I walked
by because I didn't want to be involved with him. I'd found him
repellant. But I don't like the part in me that found him repellant.
Who knows how he ended up in that state?

**Who is to say whether it's right or wrong for a man
to just let himself go?**

Nobody.

**According to Californian law the homeless are not to be put in asylums.
As a result of that thousands are living on the streets, many of them
mentally ill, and nobody really seems to care—they just let them go astray.
So did the man on the bench, who seemed rather non-heroic and
non-exceptional, at least enjoy the freedom of doing as he pleased?**

James Boswell in his life of Samuel Johnson's writes: "What signifies,
says someone, giving halfpence to a common beggars? They only lay
it out in gin and tobacco," to which Johnson replies: "And why should
they be denied such sweeteners of their existence? It is surely very
savage to refuse them every possible avenue to pleasure..."—I always

loved that. It is as close as I can come to believe that there is some value in just being a living person, a value that transcends or is more primary than anything else. Intellectually I can't defend that view but I can feel it. Because we all deserve mercy as human beings, doing the best we can with whatever we have. Some people can't make anything of it. But you can't write them off because they can't. That's a cause for pity not for condemnation.

In the last two decades, many people in both Europe and the United States but especially the U.S. appear to be losing any sense of our common humanity. I've always believed that, given enough time, people will discover their own best interests and that, those best interests are tied to the interests of everyone else. But for the current Republican administration in Washington and for a broad band of Republicans nationally, there is clearly a growing conviction that freedom means doing whatever one wants without any sense of responsibility. This shallow definition of freedom is often accompanied by the belief that if someone else receives a government benefit, it must have been taken away from you. This leads to the paradox of Americans voting against health and retirement benefits that they themselves absolutely need. Or to the strangeness of insisting on their right to expose themselves to the Corona virus even though it means others may spread the virus to them or they might spread it to the others. That the great American experiment should be reduced to such blind selfishness is breaking my heart, and that is even before one considers the extent to which the wealthy have captured democracy for their own selfish benefit.

Not until the election of Donald Trump -- with his campaign waged in aggressively racist, sexist, narrowly nationalistic and violence—did I realize how much I had thought of my career as contributing in some measure to a more tolerant, equal, and just United States. I would not have believed that the people I grew up with in Wisconsin—with their strong Scandinavian, co-op oriented, historically somewhat socialist, church-going background—could possibly vote for Trump. I thought the people I knew would not even have let him join their church fellowhips. This shock has led me to question whether I have spent my life as productively as I had thought.

I had long been interested in German social democracy. To me the example of Europe's and Germany's substantial commitment to social democracy is essential if the United States is ever to commit itself to a greater degree of social welfare. It was my good fortune of to be recruited in 2017, just as I was stepping down at CalArts, as founding director of the Thomas Mann House in Los Angeles (and now as chair of its Los Angeles Advisory Board), with a mandate for US-German exchange and inquiry around issues of the future of democracy and the liberal order. The work with this institution has given me an occasion to learn more about Germany's history and the post-war establishment of democracy and also about American political and social history. What I have learned about the American past, about the continuing struggle between social and economic inclusion and exclusion, has been in almost equal measure dispiriting and encouraging: dispiriting because of truly terrible, nearly unforgivable individual and governmental actions in the past and present,
and encouraging because the struggle for a better country has never ceased and is still very much alive. Similarly, what I have learned about the collapse of the Weimar Republic, with all its analogies to the current situation in the United States, has taught me a great deal about the potential fragility of the democratic enterprise, while the rapid development of democracy in Germany after World War II has encouraged my faith that people individually and as a nation, with better leadership, can build a more just world despite the inheritances of the past. I've realized, in short, that the struggle for social and economic justice and for true democracy is endless.

Today I think the United States needs Germany's example almost as much as Germany once needed the United States. To be heartbroken about current circumstances is an indulgence that we cannot afford. I feel obligated to carry on the struggle as others did before me. I think it is my father's feeling of obligation to carry Judaism into the present and future that has shaped my sense of obligation to continue the struggle for a just democracy. As so often, it is what one sees at the individual human level that shapes what one thinks is possible for the greater polity.

**With this in mind, do you believe that kindness is
what holds people together and ultimately rules our fate?**

I value effort and therefore believe that kindness is a common
humanity we're able to extend even to people we don't really like.
That it is something we can do. Jürgen Habermas says if we're going to
have a future then we're going to have to learn how to extend our
fellow feeling to people who are not just our neighbors or not just
close to us or in the same nation but far away. And we're going to have
to recognize that we share a common world. I can't get my heart far
out enough to fully take that in, it's stuck closer to home. But I feel
that one of our challenges as a species now is to find a way to extend
our understanding of shared humanity beyond the realms in which
it's "easy." There's a beautiful moment in Janet's book *White Matter*,
when her father cuts the hair in the back of uncle Benny's head,
a relative who's been lobotomized years before and lives in an asylum.
He does it because he knows that Benny cannot reach there, in a
gesture that to me embodies the way we ought to be connecting in this
world. Having said that, I'm aware of still protecting myself too much
from feeling the ultimate value of human connections as opposed
to what a job or a school needed from me. Therefore, one of my
challenges is to extend that, mercy to myself. I feel it's dumb luck
that I was given the chance to do what CalArts has let me do. Because
I'm not sure what I could have made of my life in another setting
or how I would think about my value as a human being.

Santa Monica Beach towards Pacific Palisades, 2017

OVER THE RAINBOW—A BRIEF HISTORY OF CalArts

Life has many colors. Their shadings may differ depending on who we are, where we live, and what we perceive. Sometimes they seem to be shining a little brighter—such as in a place like Los Angeles.

I was mesmerized and muzzy when I arrived at LA International Airport for the first time. Looking up the radiant blue sky while stepping out of the plane seemed like a different reality. Compared to Berlin, a city not too blessed with sunshine, Los Angeles was all about lights, shadows, and reflections, even at night. Gazing down from Griffith Park or Mulholland Drive, the city, like an endless field of diamonds, lay glimmering beneath my feet. In the mornings, as

I remember them from my time spent in Pacific Palisades, the reflections from the ocean seemed to intensify and brighten the colors around me. The ever-present lights and illuminations of Los Angeles—they shape everything from places to people and their mentality.

City beyond Limits

LA is giant—a megalopolis of exorbitant variety and so far spread out you can drive for hours without leaving its boundaries. But however carefully you may have checked your route, you can always get stuck in a sea of engines. Driving in Los Angeles is all about shuffling along the freeways, highways, interstates, or motorways. Forced into the never-ending maelstrom of metal, cement, and concrete, cellphones are what connect people to what they assume is life, although in reality they're pretty much cutoff from humanity. Millions are on their daily way in order to keep the urban colossus going: craftsmen, clerks, costume and set designers, model builders, light technicians, seamstresses or assistants—most of them working out of sight, even in Hollywood. They're on their way, struggling to exist. It helps to be determined in Los Angeles, not just strategically or geographically but also emotionally. Without determination life in LA can be pretty bleak and lonely.

At first glance the city appears to be open and dynamic, bursting with energy. There is a different side to the surface, but it takes some investigation for it to unveil. To start with, imagine a face you spot in the crowd, somewhere in the city. Whatever your initial impression is you would likely be surprised by that person if given the chance to get to know them personally. Because in Los Angeles keeping up appearances is everything. And people know how to play their part convincingly. In a culture defined by media and movies, in a social context increasingly shaped by virtual reality, in a city of exuberant dimensions, they lose touch not just with one another but with their identity. LA is full of actors, players, drifters, and gamblers. And there are dawdlers, beggars, hookers, homeless people hanging around and strangers or tourists looking for distraction, amusement—any kind of company. Nowhere else have I so vividly felt people being so fundamentally lonely, abandoned, exposed to the streets. They are passengers of time on a journey going by quite fleetingly. Life is about the moment more than anything else in Los Angeles. Angelinos seem lost in their present just as much as Europeans are lost in their history.

And yet LA is fascinating. Because to the same extent that it is a place of fluctuation and make-believe, it is also a place of openness and diversity. Although quite visibly shaped by immigrants from Asia, Mexico, and Latin America, what you feel is that there are people from all over the world anytime everywhere—people driven by hope and ambition, generating a spirit that is liberal, experimental, entrepreneurial. What was true of New York in the 1960s or 70s can be said about Los Angeles today: there is risk, discovery, creativity. Anything seems possible if you have a good idea, are willing to try it out, work hard, and commit yourself to it. In a way Los Angeles is the city beyond limits.

Walt Disney's Vision

A man who was well aware of LA's opportunities and way ahead of his time was Walt Disney. Originally from Chicago and trained as an animator for advertising, his sparkling, multicolored fairytales turned out to be not only an ideal place of distraction for his audience, they also sold widely. If it's actually true that Disney arrived in LA with only forty dollars in his pocket, then his business instincts were amazing.

Being a perfectionist in nearly anything he did, Walt Disney valued diligence and solid artistic training. Los Angeles—due to advertising, theater, Vaudeville and the movie industry—provided the creative potential Disney needed for his production company. Constantly looking for professional artists he took an early interest in the Chouinard Art Institute, a leading local art school run by its namesake, the artist and educator Nelbert Chouinard (1879–1969). At a time when Disney had no money, Madame Chouinard agreed to train his first animators on a pay-later basis. Soon, Walt himself became a financial backer of the school. Since he preferred to recruit classically trained artists whose craft would meet specific studio expectations, many of the animators who worked on early Disney movies were Chouinardians. When Snow White and the Seven Dwarfs (1937), Disney's first animated feature, was given an honorary Academy Award, the company's golden age of animation began. The next two decades would bring a veritable parade of beautifully crafted animated films—Pinocchio, Fantasia, Bambi, Cinderella, Peter Pan, Lady and the Tramp, Sleeping Beauty, and 101 Dalmatians—all now cinematic classics.

Chouinard Art Institute, Los Angeles, around 1930

But as the 1960s waned it became apparent that the wildly successful entertainment empire Walt had founded in 1923 with his brother, Roy O. Disney, as the Disney Brothers Studio, was beginning to lose its way. Its animated films had lost much of their luster and Disney's original supervising animators were either dying or retiring. Disney had not gone out of his way to train new people; thus nobody was being trained in full animation anymore except at his studios.

However deep into his fabled career, Walt had begun to conceive a school that would not only train young animators but nurture future generations of creative spirit.

In 1961 the Disney brothers started turning this vision into reality. By merging the Chouinard Art Institute and The Los Angeles Conservatory of Music—both of which were then going through financial difficulties—California Institute of the Arts came into being. Three years later, at the Hollywood premiere of Mary Poppins, Walt Disney introduced his concept for CalArts to the public. Like the other major project occupying the last years of his life,

CalArts as a vision, Los Angeles, around 1960

EPCOT (Experimental Prototype Community of Tomorrow), CalArts was a decidedly utopian undertaking. Walt saw the college as part of LA's brand-new, world-class cultural infrastructure, alongside the LA County Museum of Art and The Music Center. He imagined the school functioning, on the one hand, like a Renaissance workshop, with masters and apprentices painting and drawing side by side, and on the other, like the nearby CalTech, where teams of scientists from different disciplines worked together to invent new technologies. Disney's vision was to bring all of the arts together in one institution of higher learning, resulting in a kind of cross-pollination that would bring out the best in its students. "CalArts is the principal thing I hope to leave when I move on to greener pastures," Walt Disney said. "If I can help provide a place to develop the talent of the future, I think I will have accomplished something."

In 1965, the Alumni Association was founded as a nonprofit organization, governed by a twelve-member board of directors to serve the best interests of the institute and its programs. Members included leading professional artists and musicians who contributed their knowledge, experience, and skill to

CalArts construction site (southeast), Los Angeles, 1969–1970

strengthen the institute, among them Edith Head, Nelson Riddle, and Henri Mancini. Following Walt Disney's death in 1966, the Disney family and other benefactors pressed ahead to bring his vision to fruition. Disney had traded ranch land he owned for the site of CalArts's future campus close to the freeway, and he had bequeathed roughly half of his fortune in the form of a charitable trust to the Disney Foundation. Ninety-five percent of that bequest would go to CalArts. Before long some $36 million was spent to begin construction on a starkly modern campus in Valencia, amid the barren hills north of Los Angeles.

From Chaos to Creativity

The groundbreaking for CalArts' future campus (a five-level, 500,000- square-foot "mega-building" as its centerpiece designed by architects Ladd & Kelsey) took place on May 3, 1969. But construction of the site was hampered by torrential rains and labor troubles, thus the maiden class of 659 students arrived to no classrooms. An interim campus was set up at Villa Cabrini, an abandoned Catholic girls' school in Burbank. But the early organizers faced

yet another, perhaps greater challenge: structuring a new school at a time of destructuring—a moment of intense political and social upheaval and radical critique of the educational system.

From the beginning, CalArts was plagued by the tensions between its art and trade school functions as well as between the non-commercial aspirations of the students and faculty and the conservative interests of the Disney family and trustees. The founding board of trustees originally planned on creating CalArts as a school in an entertainment complex, a destination like Disneyland, and a feeder school for the industry. However, in an ironic turn of fate, the board appointed Dr. Robert W. Corrigan as the first president of the institute. Corrigan, former dean of the School of Arts at New York University, fired almost all the artists and teachers initially hired from Chouinard in his attempt to remake CalArts into his personal vision. Subsequently, the institute's provost and dean of the School of Theater and Dance, Herbert Blau, was instrumental in hiring a number of professionals like Mel Powell, Paul Brach, Alexander Mackendrick, Maurice Stein, and Richard Farson, and program heads or teachers who largely came from a counterculture and avantgarde side of the art world like Ravi Shankar, Judy Chicago, John Baldessari, Nam June Paik, Allan Kaprow, Stephan von Huene, Bella Lewitzky, Michael Asher, and Jules Engel.

In 1970, opening its first, famously chaotic academic year at Villa Cabrini, the fundamental principles established at the Institute by Blau and Corrigan came to fruition, including ideas like "no technique in advance of need," and curricula that were to be cyclical rather than sequential, returning to root principles at regular intervals. There was emphasis on being a community of artists, some called students and some called faculty. Mel Powell called for as many curricula as students; Maurice Stein argued for doing away with courses altogether, because "courses really get nobody anywhere." Although the school did end up offering courses, schedules were intentionally loose and attendance voluntary.

Classes in computer music, world music and dance, experiments in video art and optical composite printing alongside Happenings-like performances or mushroom-hunting expeditions were among the wide-ranging spectrum. However, in the spirit of the 60s, courses like Advanced Drug Research, Chinese Sutra Meditation, Sex in Human Experience, and Society or Super-Woman: A Feminist Workshop did not reflect the seriousness—the quest for meaning in life and art—that was going on at CalArts in general.

Grasstains. A CalArts happening, Los Angeles, early 1970s

The pressures on Corrigan, Blau, and the deans to formulate a radical pedagogical vision for the new institute were certainly great, as was the magnitude of the challenge faced by CalArts professors in actually trying to implement that vision in (or out of) the classroom. But the demands of "professionalism" were frequently at odds with the demands of community, experimentation, and interdisciplinarity. Therefore, the schools took different directions. Dance, for example, under Bella Lewitzky insisted on discipline. Film directing under Alexander McKendrick was also very strict, while what became the film video program was much more free-form, with no clear definition of the skills to be achieved. Visual arts on the other hand, operating under the influence of Fluxus and then Conceptual Art, did not emphasize craft but rather extreme creativity. This was also the case with the Feminist Art program founded by Miriam Schapiro and Judy Chicago, which combined consciousness-raising sessions with research into women's issues and the history of women artists. Chicago and Shapiro's program broke with the formalist emphasis of much art and arts education of its era, encouraging students to focus on content and their personal relationship to that content—i.e. to the experience of being a woman, which had previously been discounted and/or marginalized by the universalist discourse surrounding art and art making.

Another early pedagogical experiment of note was the Post Studio art class designed by John Baldessari, who was initially hired by the school as a painter, despite the fact that he had famously burned all of his paintings in 1970. Given the same latitude as other CalArts faculty members to decide what and how he wanted to teach, Baldessari expressed a desire to work with "students who don't paint or do sculpture or any other activity by hand." Post Studio was essentially a class in conceptual art making, for which Baldessari provided primarily equipment (Super 8 cameras, video cameras, still cameras), exposure to the exciting roster of New York and European conceptual artists he brought to campus as visitors, and exhibition catalogs. "If you had enough good artists around from all over the world," he reasoned, "the students would come and they would teach each other."

Turn of the Tides

Not everyone was pleased with the freedom expressed at the newly established institute or with the ideas of its leaders, although "Corrigan and Blau in some ways were far ahead of their time, actually imagining a future in which borders among the arts dissolved and it became much less clear what set of skills each individual artists would need," as Steven Lavine concedes when asked about CalArts' early years. With the example of the Berkeley Free Speech Movement before them, Corrigan and Blau were about to hire Marxist philosopher Herbert Marcuse from Germany. But the Disneys threatened to withdraw their support, rejecting such a provocative move. By that time they had donated more than $30 million to the school, although much of it had gone to fund the building, which was lavishly equipped for art making. Before long CalArts found itself in financial trouble and Roy Disney, head of the group who controlled the CalArts board of trustees, responded to the radicalization of his brother's concept by trying to sell off the institute to a neighboring institution. Overtures were made to CalTech, Art Center College of Design, University of Southern California, and Pepperdine University, none of which were interested.

Then, by a fortunate wink of fate, Aristocats, the last feature film Walt Disney had approved to go into production prior to his death, turned out to be a huge success. As a result Roy decided to create an endowment in September of 1971, two months before CalArts moved to McBean Parkway, its present address. However, Disney insisted that the brief tenure of the institute's president Rob-

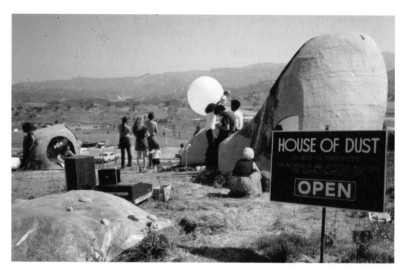

Poem in Progress, CalArts, Los Angeles, 1972

ert Corrigan and provost Herbert Blau had to come to an end. In 1972, Corrigan was replaced by William S. Lund, a Disney son-in-law. According to a story in The Times, Lund arrived amid a "bushy-headed, braless and barefoot student body." As temporary president, he promised no major changes. However, a month later, fifty-five of CalArts' 325 faculty and staff were fired. Structured schedules were introduced and classes were trimmed back—with one exception: since the Disney studio was having trouble finding qualified animators, CalArts established an animation department. Within a year, the institute was operating on budget. Some credit Lund with saving CalArts. Others see his tenure as the end of an idealistic experiment. For good or bad, CalArts persevered.

In 1975, Robert J. Fitzpatrick, professor of medieval French literature and dean of students at Johns Hopkins University, was appointed new president of CalArts, holding this position for twelve years. Fitzpatrick's charge was to assure fiscal solvency to the institute, make "all the divisions separate, to give each dean complete autonomy in his field, and to make the intermingling available to the students who could benefit from it a resource, not an obsession." Ambitious and only thirty years old, Time Magazine listed Fitzpatrick among the country's "200 rising leaders." CalArts was calm when he arrived,

but he quickly stirred things up with his trademark combination of bluntness and idealism. At a trustees meeting—held on the corner of Mickey Avenue and Dopey Drive at Disney headquarters—the new president delivered a do-or-die ultimatum: either pour $10 million into the institute or shut the doors. CalArts got the money. Next Fitzpatrick persuaded several board members to resign and brought on names like wealthy businessman Jon Lovelace and Edie Wasserman, wife of MCA chairman Lew Wasserman. He even encouraged teachers to start giving grades: "I'm sure," Fitzpatrick said, "those early years at CalArts were a wonderfully euphoric period. But it couldn't have lasted and it shouldn't have lasted. At some point, faculty has a responsibility to teach and students have a responsibility to learn." Fitzpatrick had little reverence for the institute's founding vision—either Walt's version or Blau or Corrigan's. He did a lot to bring greater order and regularity to the school, however, much of his attention was directed outward. On any given night, he would show up at two or three parties around town to "carry the word" about CalArts. He was famous for working a room. When he attended theater or concerts he would arrive at the very last moment so the entire audience witnessed his entrance. "I've never been notorious for my humility," he said. Courting Wasserman, who agreed to donate $100,000 if Fitzpatrick wouldn't smoke during their meeting, he immediately put out his cigarette. Over the course of thirteen years, Fitzpatrick raised $58 million for the institute.

Saving CalArts

When Fitzpatrick resigned as president to head Euro Disney in Paris, Nicholas England, former dean of the School of Music, was appointed acting president until, on October 23, 1988 Steven D. Lavine, associate director for Arts and Humanities at the Rockefeller Foundation, came into office. "Part of what attracted me to CalArts was the passionate commitment to teaching and learning visible throughout the institute," as Lavine remembers. Inaugurated in a Santa Monica ceremony that featured Javanese gamelans and African drummers, various music and dance performances, among them a solo by choreographer Trisha Brown, Lavine's nearly thirty-year tenure was to become the longest not only in the history of CalArts, he would also be one of the longest-serving college presidents in the United States.

Initially Lavine wasn't sure he could save CalArts from mounting debt. The budget already approved for 1988–89 was, in fact, the third year of a growing deficit that had become structural and was gradually depleting the college's small endowment. Enrolments were flat; faculty members were struggling to defend their programs in a declining situation; and the board of trustees was demoralized. Indeed, Roy. E. Disney—in many ways the key trustee because of his own personal generosity, his role as a board member of the Walt Disney Company (CalArts' other key supporter), and his family's long history with CalArts—was planning to leave the board. Lavine was able to convince him to remain. Central to his decision was Lavine's commitment to diversify CalArts' sources of support and multiply giving from non-Disney sources. Lavine created a plan for stabilizing CalArts' finances through enrolment growth and a fundraising campaign. Both measures proved to be successful. The campaign that aimed at $25 million eventually became $55 million. Next Lavine began a process of board renewal with the appointment of a significant number of new trustees, including Norton Utilities founder and philanthropist Peter Norton, Disney studio executive Jeffrey Katzenberg, philanthropist George Boone, and civic leaders like Janet Dreisen Rappaport, Larry Ramer, or Richard Seaver.

Over the next several years, as enrollments grew steeply, Lavine led the process of upgrading existing facilities and building new ones, including twenty new art studios and sound stages for the schools of film and theater. To amplify CalArts' international reputation as an institution committed to the support of the individual creative exploring artist, Lavine launched in cooperation with the Herb Alpert Foundation, an annual national fellowship program for mid-career artists, the Roy Disney Alpert Award. When he discovered that CalArts was not seen as a core LA institution and, therefore, not commanding major gifts from local foundations and many individuals concerned with LA's cultural growth, the president actively engaged in Los Angeles' cultural and artistic issues. He joined a number of boards and was recruited to a broad range of national initiatives, including the American Council for the Arts and the American Assembly's Arts and Government Program. Two decades later, this line of activity lead to Lavine becoming the only college president asked to serve on then Senator Obama's arts policy committee. And last but not least seeing that the youth in many parts of Los Angeles had little or no access to serious, sustained education in the arts, Lavine devised and launched the CalArts Community Arts Partnership (CAP), an initiative creating opportunities for over 300,000 underserved youth. Today CAP works with CalArts faculty and stu-

With Jeffrey Katzenberg (left), Steven Spielberg (centre) and Beverly O'Neill (right), Los Angeles, late 1980s

dents to provide school and community-based arts instruction in some fifty different programs spread across the Los Angeles basin. While establishing CalArts as a responsible citizen of greater Los Angeles, CAP has also led to CalArts becoming one of the most ethnically diverse arts schools in the United States.

By 1994, CalArts was thriving, with a reinvigorated board, new administrative and faculty leadership, expanded facilities, balanced budgets, a growing endowment, and a rapidly expanding student body and applicant pool. Then, in January 1994, the campus was shattered by the Northridge earthquake. All of its educational facilities were redtagged by the state as unsafe to enter, threatening not only the continuance of the semester then in progress but the sur vival of the institution as a whole. Lavine and his leadership team determined that the semester's educational program must continue so that the loss of tuition would not compound the economic challenge of rebuilding the campus.

In a meeting held in front of the steps of the ruined institution, Lavine turned to faculty, staff, and students telling them: "We're going to go on. For those of you who stay, this will be the most important semester in your life. It will prove that you can make art no matter what happens."

With Lavine's guidance, the help of trustees, and other supporters who connected CalArts with resources to recover and rebuild, the school pulled through. In a two-week period the entire educational program was moved to fifteen newly rented sites spread across the Los Angeles basin, with the result that 85 percent of the students chose to brave the semester. Alongside the relocation of all its programs and technical facilities, CalArts launched an aggressive rebuilding effort, involving round the clock construction shifts, six days per week, which were necessary if the campus facilities were to be restored in time to enroll a new class in the fall. This enormous challenge was met and CalArts reopened its restored and improved facilities to full enrollment eight months later in September 1994. Meanwhile Lavine had successfully campaigned in Washington, D.C., lining up the necessary support from California senators and congressmen so that CalArts would not find itself in the position of other shattered institutions that had to wait years for FEMA (Federal Emergency Management Agency) funding. By August 1994, FEMA had awarded $28 million toward the rebuilding of CalArts, with the remaining $14 million needed to cover the full reconstruction cost of $42 million raised from individuals and foundations, the Getty Trust among them with an unsolicited contribution of $2 million.

Though the earthquake was devastating, surviving it was an important milestone. CalArts' remarkable recovery had a positive impact on both the school's reputation and Lavine's own. Over the following years, he was approached for a number of prominent leadership positions, all of which he resisted to accept. Experiencing the spirit of a CalArts coming together for the greater good and rebuilding an even better institution after the Northridge Earthquake was life-changing for him: no longer a president who would pursue the next larger opportunity, Lavine found that CalArts was more than a job—it was a vocation. In a similar way many faculty and staff, who had previously feared that CalArts was too idealistic and too utopian to survive and that it would, like the Bauhaus and Black Mountain College, have its impact and then disappear, were filled with new energy.

Back to the Future

The reconstruction started an epoch of growth and innovation. Lavine led a campaign that eventually raised $150 million in endowment, capital, and an-

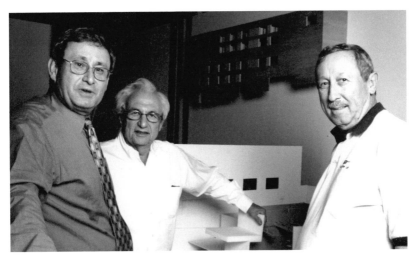

With Frank Gehry (centre) and Roy O. Disney, Los Angeles, 1990s

nual fundraising. New programs and degrees including an MFA in Creative Writing, an MA in Aesthetic and Politics, an MFA in Art and Technology, and a Doctor of Music for performer/composers were launched. With major endowment gifts, the School of Dance became the Sharon Disney Lund School of Dance and the School of Music became the Herb Alpert School of Music at CalArts. Moreover, the Center for New Performances was established, producing ambitious work meant for national and international presentation.

When Lavine realized that many CalArts graduates felt they had to leave LA to pursue their careers, and that the city needed a performing and visual arts organization focused on the early careers of artists in all fields, CalArts launched a new performance space in downtown Los Angeles. The Disney Company had made a $25 million donation for the construction of the Walt Disney Concert Hall. With the proviso that $5 million become the core endowment for a yet-to-be-designated space for CalArts, Frank Gehry, the architect of the concert hall, found a way to insert a space in the southwest corner of the building, while Lavine raised the $14 million to build it—a state-of-the-art facility for music, theater, dance, cinema, visual arts, and multidisciplinary work. In 2003, less than a decade after the Northridge earthquake, REDCAT—short for The Roy and Edna Disney CalArts Theater—opened its doors. As a professional

Three CalArts Presidents: Steven D. Lavine, Ravi Rajan, Robert Fitzpatrick (from left), Los Angeles, 2017

arts presenter, it expanded the perception of CalArts not only locally but nationally and internationally.

Since 2008, CalArts has entered a new phase in its development. After two recessions and a fluctuating philanthropic environment, and with more students financially able to attend elite educational institutions, CalArts established a number of initiatives to stay at the cutting edge of art making (on-campus laboratories such as the Center for Experiments in Art, Information and Technology; the Center for Integrated Media; and the Cotsen Center for Puppetry among them). Moreover—in response to the increasing internationalization of the art world and the understanding that CalArts students must be prepared to operate internationally—new exchange and cooperative programs were set up with universities in Korea, China, and Mexico as well as with international artistic and cultural institutions including the Cent Quatre Center in Paris and PACT Zollverein in the Ruhr Valley of Germany. In addition, CalArts started a number of short-term intensive programs for international students that would both further that internationalization and were designed to be profitable enough to help sustain CalArts as a whole. And finally CalArts

moved into online education to both extend the reach of CalArts and to generate additional financial reserves for the institute.

CalArts today according to writer Janet Sarbanes, "is a school rather than an anti-school with grades, a timetable for graduation, and for the first time in its history, a syllabus in every classroom. Yet an investment in radical pedagogy persists, with a loose consensus that the educational situations that work best often involve field trips and social outreach, project-based learning, and 'mentoring' as opposed to 'teaching.' The notion that faculty are to treat students as artists and colleagues prevails, with its attendant benefits and difficulties. The question of what form the delivery of content should take is a live one. Time and space are continually contested, and an openness to what might be places constant pressure on what is. Subsequently the institute has carved out a 'commons' time from the heavily scheduled individual school curricula in which students can come together across disciplines to collaborate—in some sense, a return to its origins. Although, to paraphrase Herbert Marcuse, an art school can only be truly free in a free society—i.e., art becomes life only when life is also opened up to creative change—the promise of this commingling endures. Indeed, the Gesamtkunstwerk that preserves a vision of emancipated social life in times of political conservatism holds even greater possibilities in our own era of collective action and renewed resistance." This may be one of the reasons why CalArts is where any young aspiring artist would want to be. Besides few any colleges have as many highly ranked arts programs focusing on contemporary art and multidisciplinarity and the institute's stated mission is to develop professional artists of tomorrow—artists who will change their field. With these goals in place, the institute encourages students to recognize the complexity of political, social, and aesthetic questions and to respond to them with informed, independent judgment, and critique. As a result, many of CalArts alumni have won Oscars, Pulitzer Prices, and Guggenheim or Mellon Fellowships. Ranked among the ten best fine arts programs in the United States by U.S. News & World Report, CalArts is recognized alongside Black Mountain College and the Nova Scotia College of Art and Design as one of the truly successful experiments in American arts education.

Steven Lavine, who is to a great extent to be credited for these achievements, decided to leave the institution in 2012 (although it took another five years until he finally handed the reins over to his successor Ravi Rajan in the fall of 2017). Thousands of students have graduated from CalArts during Lavine's long tenure. They have heard his annual addresses either saluting them as

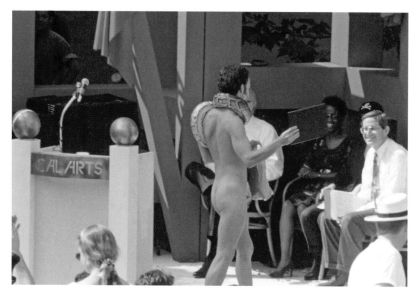

Approached by a naked graduate dressed with a Boa Constrictor at a CalArts graduation ceremony, Los Angeles, 1990s

freshmen or wishing them well as graduates who were about to leave the institution. Asked about a memorable moment, Lavine recollects one of the graduation ceremonies during which a guy sat in the audience with nothing but a boa constrictor around him. Lavine, while handing out the degrees, was extremely frightened: "I'm terrified—terrified!—of snakes," he remembers. "So the provost went down and asked the guy if he could leave the boa constrictor behind because the president was going to faint. And the guy just said: 'I can't do that. I'd be totally naked!'"

Upon closing his last graduation speech in 2016, Lavine couldn't hold back his tears: "I wish you rich, fulfilling creative lives," he addressed the students. "Stay in touch. Grapple with your CalArts friends and help them in every way you can. Wherever I find myself, I will be watching you with pride and admiration." Leaving the stage with a last look and a little nod towards the crowd, Lavine was given a standing ovation. Although he has moved on to become the founding director and chair of the newly established Thomas Mann House, a German cultural center in Pacific Palisades, it is pretty obvious

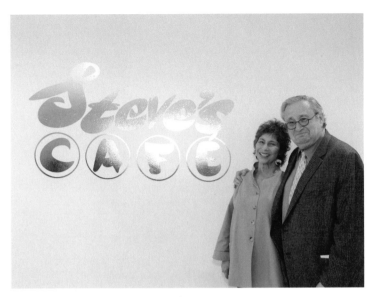

With his wife Janet Sternburg, Los Angeles, 2017

where he will be remembered most for his lifetime achievement. There is a coffee spot next to CalArts' refectory called Steve's Café, lending weight to its namesake with a plaque featuring an engraving of his image. May the students and alumni frequently salute him while enjoying their daily coffee break.

Jörn Jacob Rohwer*

*With special thanks to Janet Sarbanes whose article "A Community of Artists: Radical Pedagogy at CalArts, 1969–72." (East of Borneo, 2014) inspired me to write this essay. JJR

ACKNOWLEDGEMENTS

This book is dedicated to all the people who have gently contributed to its emergence. In a way it is a demonstration of friendship—shared with those who have been close to me for many years as well as others whom I have met more recently. Similarly this book—in an era when the Atlantic seems to widen politically—is a demonstration of German-American relations—brought forth by those in the United States who have trusted in my vison and encouraged it from the very beginning and others in Germany who value my authorial craft. Besides it is a stroke of good fortune that DeGruyter, the family owned publishing house established in 1749, releases and trades arts and academic books both nationally and internationally, thus contributing to unite this divided world with knowledgeability.

In view of that, I would first and foremost like to express my gratitude to Steven D. Lavine who has granted me his trust so generously. He even has had the bravery to agree to the book's somewhat tricky title. It's been a great pleasure to work with him all the way. Interestingly though it was Janet Sternburg, his wife, who, long before Steven and I would have even taken it into consideration, envisioned this book. Janet inspired it, believed in it and paved the way for me to actually work on it. Without her this publication would not exist. In an equally important way Janet's friends, Daniel Greenberg and Susan Steinhauser have helped this book come to fruition. Their amazing spirit and generosity gave me strength and carried me through the task of moving forward throughout the past three years.

On the more practical side I'd like to thank everyone from CalArts who facilitated the advancement of my work in Los Angeles—Brian Harlan, Elizabeth Robison, Margaret Crane, Stuart Frolick, Denise Nelson, Amanda Cruz Echavez, Trish Patryla, Kathy Carbone, Brena Smith, Karla Talavera and Judy McGinnis among them. Jim Wolken was always there when I needed him. Christina Niazian was an splendid assistant, spending hours over extra researches. And the wonderful Martha Carr watched over me like a friend.

As for the German team, namely of DeGruyter Publishing, my special thanks go to Jasmin Fröhlich, then aquisitions director at Deutscher Kunstverlag, who

discovered and helped to establish this book in the stages of beginning. Subsequently Dr. Pipa Neumann, editorial director, took over, being ever gentle, collaborative and ecourageing—like her colleagues Dr. Anja Weisenseel, David Fesser and Eric Smith who joined in. Just as important a part of the team were Kerstin Protz, most professionally handling the actual production process, and Martin Mosch, who delivered the signature design of this book. I would also like to thank Zita Jeukendrup and Nicole Schwarz who oversee the marketing department nationally and internationally. Without their tremendous commitment their would be hardly any reader, not only of this book.

It may seems self-evident and yet it is equally important to me to mention that no author would ever be able to live and function without the love, spirit and support of good people around him personally. There was, most notably, Michael Storper, who, aware that I arrived to Los Angeles in a time of grief, consigned his apartment to me—this sunny haven of peace and privacy, where I was able to read, write and rest undisturbedly. His brother Jonathan was kind enough to entertain me now and then and introduce me to that fairytale of a forest, Muir Woods. Both of them, in turn, would not be in my life if it wasn't for Ralf, who's often been making this world a lighter place for me in the past ten years. Like Sientje, Rüdiger, Anne, Wiebke, Bernd, Matthias and other close ones he will always be a part of my family.

My deepest gratitude goes out to those remembered, who have been examples to me as mentors, thinkers and exceptional people, most of all my mother, Hanna—and, not to be forgotten, Michael F. Shugrue, Lotti Huber, Ilse Rewald, Hans Keilson, Marion Dönhoff, Robert Wistrich and John D. Klier.

Last but not least I would like to thank you, dear reader, for spending your time with this read. I hope you enjoyed it. If there are any thoughts or queries you would like to raise, please contact me and I shall make an effort to get back to you personally. (www.jjrohwer.de)

About the Author

Award-winning author Jörn Jacob Rohwer is well-known for elegantly merging elements of literature and journalism in his writings. Widely published since 1995, his lengthy profile conversations with luminaries from the arts, science and society are best represented by his book of nearly 900 pages, "Die Seismografie des Fragens" (Salis, Zurich, 2014—currently in English translation.)

Rohwer was born in 1965 in Rendsburg, Germany, and graduated with distinction from UCL, London University. He received numerous international fellowships and foundation grants, lectured and read in Germany, Switzerland and the USA. His subsequent, seventh book is intended to comprise a collection of biographical essays. Besides writing, Rohwer works in arts communications and lives in Berlin.

PICTURE CREDITS
With courtesy of CalArts (photo archive), Mirko Nowak (Villa Aurora archive),
Steven D. Lavine (private archive), Jörn Jacob Rohwer (private archive).

LAYOUT & COVER
hawemannundmosch, Berlin

PRINTING
DZA Druckerei zu Altenburg GmbH, Altenburg

Bibliografische Information der Deutschen Nationalbibliothek
Die Deutsche Nationalbibliothek verzeichnet diese Publikation
in der Deutschen Nationalbibliografie; detaillierte bibliografische Daten
sind im Internet über http://dnb.ddb.de abrufbar.

© Deutscher Kunstverlag GmbH Berlin München
Lützowstraße 33
D-10785 Berlin
Part of Walter de Gruyter GmbH Berlin Boston
www.deutscherkunstverlag.de
www.degruyter.com

ISBN 978-3-422-98155-3